MW00618820

IMAGES
of Rail

LOS ANGELES RAILWAY
YELLOW CARS

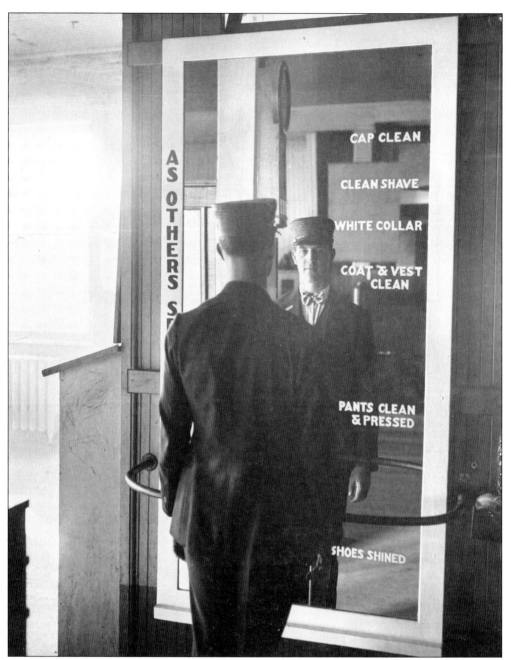

This view, taken at Los Angeles Railway's Division Three in the 1930s, shows a "rookie" standing at a mirror to make sure he meets up with the expectations his position demanded "back in the days." The expression "As Others See You," to the left of the mirror, reemphasizes this. (Courtesy Metro Library.)

ON THE COVER: Looking north on Broadway, a principal thoroughfare through downtown Los Angeles is seen in 1938. This photograph was taken from the roof of the Los Angeles Railway (LARY) headquarters building at 1070 South Broadway. Some of the LARY's large fleet of Yellow Cars are in the center lane. (Courtesy Metro Library.)

IMAGES
of Rail

LOS ANGELES RAILWAY
YELLOW CARS

Jim Walker

ARCADIA
PUBLISHING

Copyright © 2007 by Jim Walker
ISBN 978-0-7385-4791-6

Published by Arcadia Publishing
Charleston SC, Chicago IL, Portsmouth NH, San Francisco CA

Printed in the United States of America

Library of Congress Catalog Card Number: 2007926149

For all general information contact Arcadia Publishing at:
Telephone 843-853-2070
Fax 843-853-0044
E-mail sales@arcadiapublishing.com
For customer service and orders:
Toll-Free 1-888-313-2665

Visit us on the Internet at www.arcadiapublishing.com

*This book is dedicated to the men and women who staffed the Los
Angeles Railway, its predecessors and successors, both on the streetcars
and buses and behind the scenes in many other positions.*

CONTENTS

ACKNOWLEDGMENTS

The author wishes to acknowledge the many publications and individuals who have provided information, images, advice, and guidance for this book. Special thanks to the Los Angeles County Metropolitan Transportation Authority (LACMTA) and its Dorothy P. Gray Transportation Library, particularly to Matthew Barrett, the library's administrator. Thanks to Jerry Roberts and everyone at Arcadia Publishing for support and assistance.

Many of the images in this book are from the LACMTA Dorothy P. Gray Transportation Library and are noted with the shorthand, "Courtesy Metro Library." Thanks to Craig Rasmussen for sharing some of the images from his large Los Angeles Railway collection. Special thanks go to Joe Moir for use of some rare images.

Please note that although the information in this book is well researched, some factual errors may have crept in. I hope that these are at a minimum. Also, the comments and opinions are only those of the author.

NOTE ON THE CONTENT: This book is a collection of images shot and collected over many decades. Due to the nature and constraints of the Images of Rail series, this volume cannot possibly be comprehensive. But it will "hit the high spots" so to speak. Unfortunately, some of the significant events in Los Angeles Railway history along the way were not recorded by cameras. So this book attempts to summarize improvements over the decades. Enjoy the images and remember that nostalgia is the "good old days," only with the glow of those happy bygone days now enjoyed with air conditioning.

—Jim Walker
Los Angeles, California
June 2007

INTRODUCTION

Los Angeles in 1870 was a dusty village with a population of only 5,728, which was little more than a third of everyone living in Los Angeles County. The county's population of 15,309 represented only 2.7 percent of California's citizens. The land booms and growth for which the city and state became known were still yet over the horizon. Transportation was by horse-drawn wagon, and it was a slow and painful experience over roads that were rocky and dusty or muddy and thoroughly rutted. Long-distance traveling by sea on sailing ships was even slower.

The first rail-borne local public transportation in Los Angeles was the Spring and West Sixth Railroad, which opened on July 1, 1874, with one open car powered by a horse. Leading the project was Judge Robert Maclay Widney, one of the founders of the University of Southern California. Riding on rails was certainly an improvement over the unpaved streets of the era.

That horsecar line grew larger and, within a few years, more of these enterprises joined it to provide new residents and new areas with local transportation. The operators also used the rail lines to reach areas where they could promote land they happened to own. The land would become more valuable, as horsecar lines decreased the remoteness of these properties. Needless to say, much of this activity was being conducted by the movers and shakers of the day.

A big step in improving local public transportation was the introduction of cable-powered cars with the October 1, 1885, opening of the Second Street Cable Railway Company, followed in a few months by the first regular operation of the Temple Street Cable Railway Company. Other cable car lines soon followed. The topography of many so-called "close-in" neighborhoods in hilly areas was traversed more easily by cable cars than animal-powered units.

The chartering of the Los Angeles Electric Railway occurred on September 11, 1886, and construction of two lines began. One traveled down Maple Avenue to Thirtieth Street, and the other was laid out from Pico Street to the Electric Railway Homestead Association real estate tract north of Pico, between Vermont and Harvard Avenues. The standard railroad-gauge line used the Daft System of bringing the electrical current to a locomotive that pulled trailers.

One feature of "Professor" Daft's system was its use of twin overhead wires with a "troller" riding the wires. A troller was a cord hanging down that brought power to the locomotive. The many derailments of the troller device from an unsolved manufacturing defect clearly dampened reliability.

An 1888 boiler explosion at the powerhouse located at Maple Avenue and Eleventh Street damaged the electricity-generating machinery. So the horses had to be relied on again to keep the line going. This blow, plus other financial difficulties, threw Los Angeles Electric Railway into bankruptcy. It never recovered. Thus Los Angeles's first try at electricity was judged a failure.

The life of cable-powered transit was short. The Los Angeles Consolidated Electric Railway (LACE) was incorporated in 1890 and controlled by Gen. Moses H. Sherman and E. P. Clark. This outfit soon converted many cable and horsecar lines to electricity and began growing into the principal electric railway operator. The last horsecar line went to electric propulsion in 1895. The last cable line was electrified the following year. By April 1, 1896, the LACE system was 100 percent electric.

The bondholders of LACE took over control from Sherman and Clark in 1895 and renamed the company Los Angeles Railway. After the electrification of all lines in 1896, LARY ran 12 lines in the Los Angeles area, aggregating 74 miles, over which 71 cars were operated.

One

THE FIRST YEARS
1874–1898

When the Spring and West Sixth Railroad opened in 1874 as the first rail line in the Los Angeles area—with one open car powered by a horse—it was in the same year that the U.S. Cavalry was still at war with the Comanche, Cheyenne, and Kiowa tribes on the Southern Plains. "Custer's Last Stand," or the Battle of the Little Bighorn, was two years off, and Alexander Graham Bell had yet to invent the telephone.

In the coming decades, the land surrounding Los Angeles would gain in value, as it was learned that crops could grow year-round in the mild Mediterranean-like climate. Eventually, Los Angeles's brown scrubby hills and flatlands, with streams that barely trickled during summers, would evolve into a great metropolis using every single mode of public transportation available.

But local transportation in Los Angeles and "close-in" suburbs in the decades following the Civil War was by horse and wagon on roads that were often rough paths through the brush. Traveling into town or just visiting neighbors in the pioneering living conditions of the hills in and around Los Angeles required a major commitment and initiative. In the 1870s, the notion of public transit and goods hauled by rail being a success was a sketchy proposition at best.

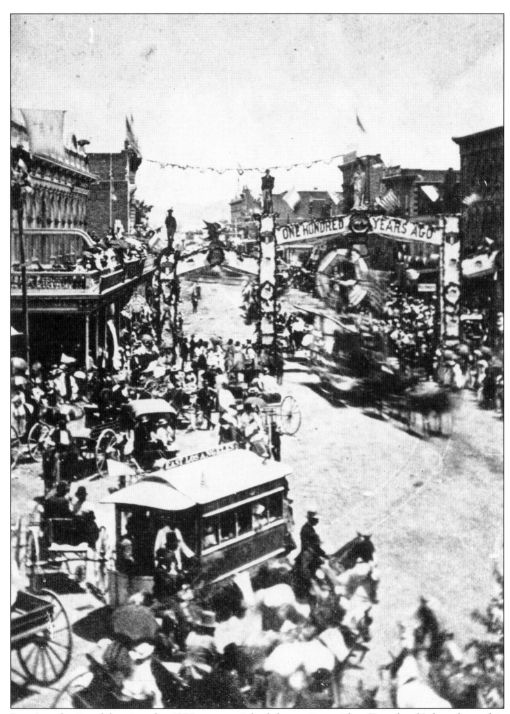

Los Angeles is celebrating the 1876 centennial of the nation with a Fourth of July gala as this image looks north on Main Street from Temple Street. A horsecar heads for East Los Angeles. (Courtesy Metro Library.)

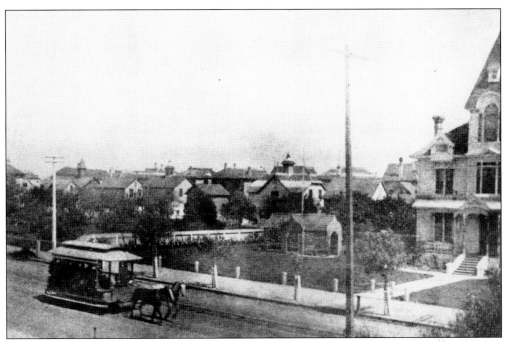

A single-truck open car, pulled by two horses, is southbound in 1886—the year it was formed—on trackage of the City Railroad, on Olive Street just north of Tenth Street. On May 1 of that same year, the City Railroad operations and those of the Central Railroad merged, although each company retained its corporate identity. (Courtesy Metro Library.)

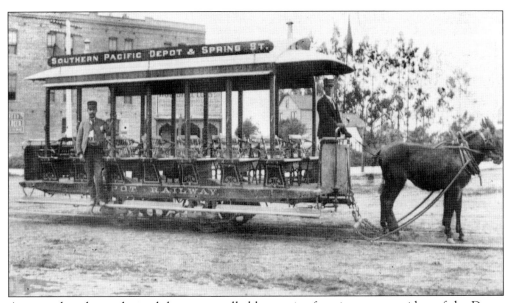

An open-bench, single-truck horsecar, pulled by a pair of equines, serves riders of the Depot Railway. The depot was Santa Fe's La Grande Station at Second and Mateo Streets. (Courtesy Metro Library.)

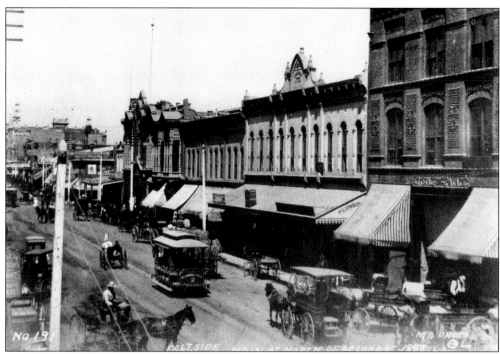

A little horsecar of the Main and Fifth Street Railroad goes north on Main Street as it heads for its terminus at First and Main Streets in 1888. (Courtesy Metro Library.)

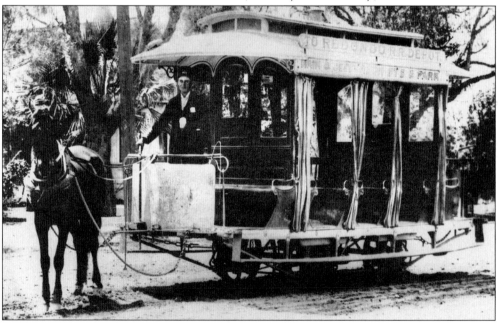

A Main Street and Agricultural Park Railway Company (MS&AP) open-bench car, propelled by a single horse, poses at an unknown location in the 1890s. This was one of the earliest horsecar lines, created in 1874, running from the Southern Pacific's River Station on North Spring Street, at about Sotelo Street, through downtown to the recreational development at Agricultural Park, which later became Exposition Park. The MS&AP was electrified in 1897. (Courtesy Metro Library.)

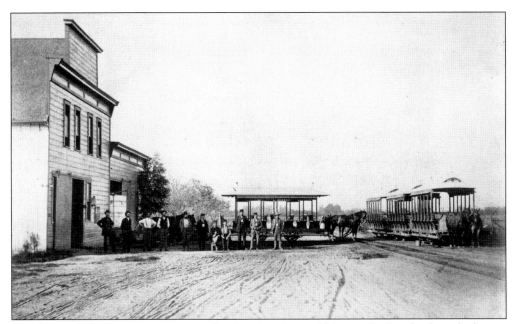

Another early horsecar operator was the Los Angeles and Vernon Railroad, whose little cars traversed Central Avenue from Fifth Street to Ballona Avenue (later Slauson Avenue). Formed in 1887, it was acquired by Los Angeles Consolidated Electric in July 1891 and was converted to electric operation on September 17 of that year. Here a group of staffers pose in front of the company's carbarn. (Courtesy Metro Library.)

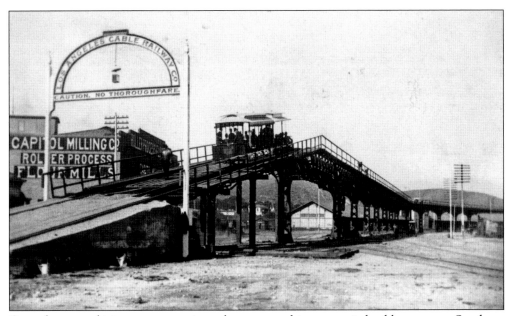

One of most ambitious structures in early transport history carried cable cars over Southern Pacific's River Yard, now known as Cornfield Park. The iron-structured bridge, often called the Cape Horn Viaduct, opened over the yard on November 2, 1889. It was last used by cable cars in 1896 and was torn down in 1907. (Courtesy Metro Library.)

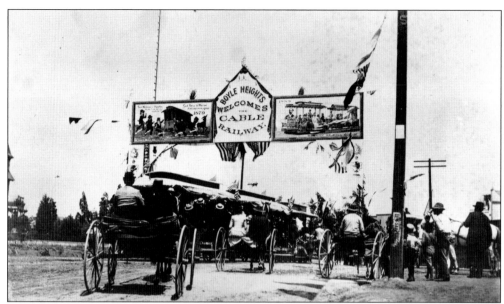

Cable propulsion came to Los Angeles in the summer of 1886. It was already widespread in San Francisco; that city had a population of 233,955 in 1880 and 352,782 by 1890. Los Angeles had a small but fast-growing population of 65,000 in 1888 and 90,000 souls by 1890. This arch sign over First Street at Boyle Avenue celebrated the opening day of the cable railway into East Los Angeles on August 3, 1889, by the Los Angeles Cable Railway Company. A month later, its property was deeded to a new entity, the Pacific Railway Company. (Courtesy Metro Library.)

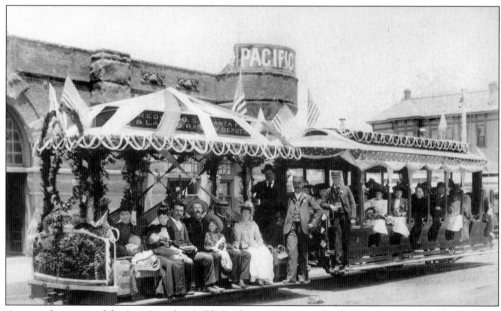

Among the assets of the Los Angeles Cable Railway Company, deeded to successor Pacific Railway, was this powerhouse and carbarn on the southeast corner of Seventh Street and Grand Avenue. It also served as the company's headquarters. The site was later used for the J. W. Robinson department store. (Courtesy Metro Library.)

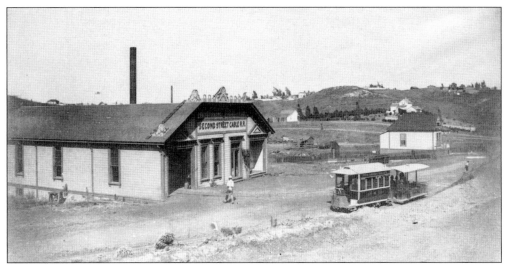

Just beginning to sprout residences, the Crown Hill neighborhood west of downtown was one of the first to develop, thanks in part to the Second Street Cable Railroad. Its powerhouse, at Boyleston and Second Streets, was this 3,300-square-foot wooden building, which also served as a carbarn. The cable line continued to Texas Street (now Belmont Street). (Courtesy Metro Library.)

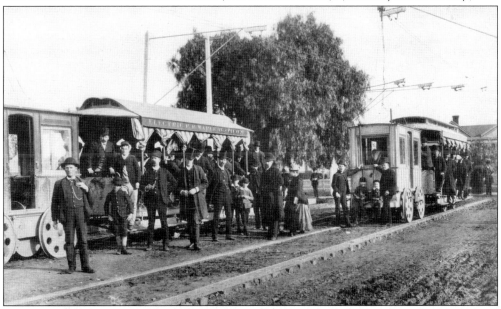

It was not long after the cable railway era had begun in July 1886 that the first electric street railway began in Los Angeles. The Los Angeles Electric Railway Company started operations on January 4, 1887, running east on Pico Street from Harvard Boulevard to Main Street on 4-foot, 8.5-inch, standard-gauge track. Most other lines used 3-foot, 6-inch track. The current connection, aptly called the Daft System, was bedeviled by a peculiarly designed (and troublesome) four-wheel carriage called a "troller," which rode on top of two wires (one positive and one negative) to collect and complete the electrical circuit. But the device was forever jumping its swaying "track." A powerhouse was built in the 1000 block of South Maple Street to accommodate needs. After its boiler exploded on June 8, 1888, the line was shut down. The enterprise went into bankruptcy and closed permanently about April 1889. (Courtesy Metro Library.)

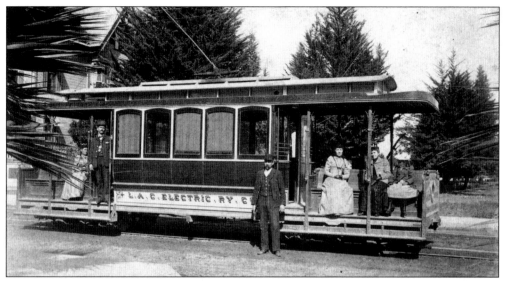

The first successful electric street railway in Los Angeles was the Belt Line Railroad Company, which planned to reopen as the Second Street Cable Railroad Company but was dissuaded by Gen. Moses Sherman, who arrived on the scene that October. The name Sherman was attached to many of the Los Angeles area's early transit, power, and land-development undertakings. Instead the line was rebuilt as an electric line, with wire current collection with the rails used to complete the electrical circuit. Soon the Belt Line became part of the Los Angeles Consolidated Electric Railway with General Sherman at its helm. This view shows LACE car No. 103 with crew and passengers in the open sections on Twenty-third Street. (Courtesy Metro Library.)

Headquarters for LACE was on Central Avenue at Wilde Street, one block south of Sixth Street. Posing in front of the newly built offices are horse-drawn line wagons. The complex also included a carbarn and powerhouse. In the 21st century, this property is Los Angeles County Metropolitan Transportation Authority's Division One. (Courtesy Metro Library.)

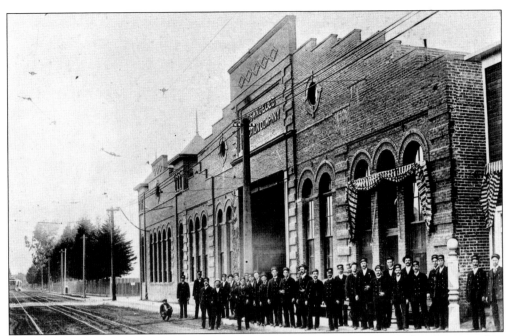

The other major streetcar company in town, and a competitor to LACE and its successor Los Angeles Railway, was the Los Angeles Traction Company (LAT), formed by William S. Hook in 1894. This 1897 view shows the front side of LAT's headquarters on Georgia Street at Twelfth Place, which included a carbarn and powerhouse. The site, used as a streetcar facility until 1963, is now part of the Los Angeles Convention Center. (Courtesy Metro Library.)

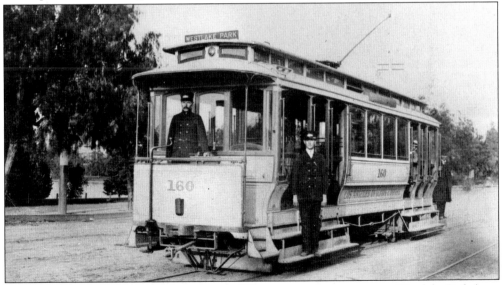

Car No. 160 of LAT is stopped for a portrait. This route took passengers to Westlake Park (now McArthur Park), then continued to its terminal at First and Virgil Streets. The company's principal, William Hook, had plans to serve additional territory and actually built a 20-plus interurban to San Pedro called the California Pacific Railroad Company. In 1903, Hook sold out to E. R. Harriman's Southern Pacific Railroad (SP). Then, in 1904, the SP resold Hook's interest, including the San Pedro interurban, to Henry E. Huntington. (Courtesy author collection.)

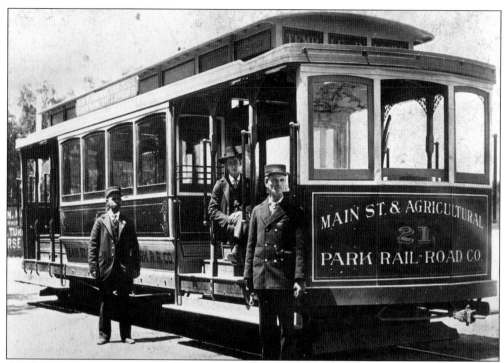

Another pioneer in electric railways was the Main Street and Agricultural Park Railroad Company, which began electric operation in 1897. It opened as a horsecar line in 1875 and was later extended into Agricultural (now Exposition) Park. It was consolidated into LARY in 1898.

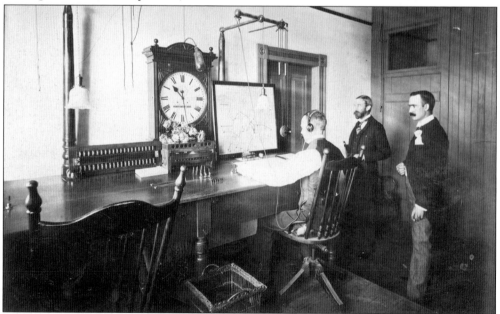

Los Angeles Railway's dispatching was done on this machine at the Central Avenue and Sixth Street headquarters, seen in this 1896 image, which was inherited from LACE. Standing at right are superintendent J. J. Akin, with the full beard, and J. L. McLean, in the large moustache. McLean installed the telephone system in the days when radio was not yet used. (Courtesy Metro Library.)

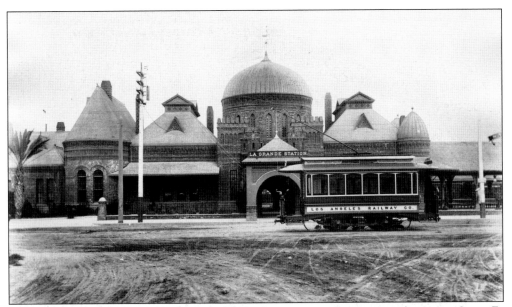

Los Angeles Railway No. 5, a single-truck closed car, awaits passengers at the ornate Santa Fe Railway La Grande Depot on Santa Fe Avenue at the foot of Second Street. Some of the depot's domes and fancy roofs of the railroad complex were removed in following years due to earthquake damage and mandated seismic protection. On the plot used for tracks and buildings now sits the yard and shops for the Metro Red Line. (Courtesy Metro Library.)

Due to Los Angeles's climate of warm days and cool evenings, particularly in summer, open-bench cars were a rarity. Instead, Los Angeles's streetcars more often used the "California" style, which featured two open-end sections and a glassed-in center compartment. The open-bench cars were often called "baseball cars" (see banner on the front) and were used to carry crowds to daytime athletic events. Many were rebuilt from old cable cars and trailers. This open-bencher became material car No. 9307. Material cars had the benches removed to make them useful for many tasks. This car went to scrap in 1933. (Courtesy Metro Library.)

The first successful electric car ran in Los Angeles in 1889. The Los Angeles Electric Railway Company began electric service in 1887 on the Pico Street Line, but it used the troublesome Daft current-collection system. The revised system, which continues to the present day, uses a wheel at the end of a pole to provide spring tension to contact a single wire, and the rail returns the electricity to the ground. On June 8, 1888, a boiler explosion in its powerhouse caused all electric operation to cease. Horsecars took over the Pico Street Line, but all its operations closed down by 1889. The company subsequently went out of business. A new company, the Electric Rapid Transit, formed in March 1890, and by October, Gen. Moses Sherman changed its name to the Belt Line Railroad Company. That operation is pictured in the above view. (Courtesy Metro Library.)

Two

THE HUNTINGTON YEARS I
1898–1910

Henry Edwards Huntington was the nephew of Southern Pacific Railroad head Collis P. Huntington. Collis Huntington was one of the "Big Four" who marshaled efforts to connect the Central Pacific with the Union Pacific at Promontory Point, Utah, in 1869 to form the first transcontinental railroad in the United States.

Henry was born in Oneonta, New York, on February 27, 1850. His advances in railroad management were swift, and his drive and knowledge were beyond his obvious advantage of having a leg up on the business due to the right connections. He and his uncle forged a surrogate father-son relationship in 1870, which remained a close mentor-student dynamic ending only with the uncle's death in 1900.

At that point, Henry Huntington was no longer heir apparent to the Southern Pacific presidency and was soon edged out of his high position in the railroad, which was the successor to the old Central Pacific. Huntington soon sold out his interests in SP and moved from San Francisco to Southern California. A big house had been built for him in the northeastern Los Angeles suburb of San Marino.

He became the central figure and biggest investor in a group that bought control of the Los Angeles Railway in 1898. At first, a management team operated the company, but when he came to town in 1900, Henry began running LARY's affairs. He had already bought other California electric railway properties—and kept doing so—but his most notable accomplishment, transportation-wise, was incorporation of Pacific Electric Railway in November 1901, which eventually expanded to parts of four Southern California counties.

The Yellow Car operation—and all of Southern California—was in a period of expansion as the 20th century began. Additional rolling stock was added, new shops built, and more car houses were opened.

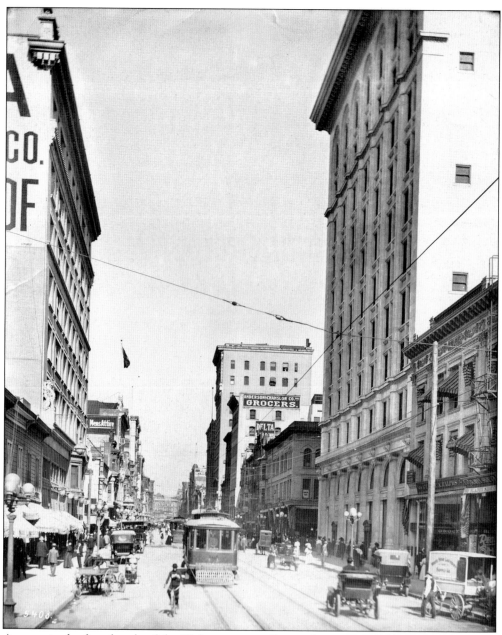

A scene in the first decade of the 20th century on Spring Street, near Fifth Street, which has nighttime lighting from the candelabra ornamental fixtures at curbside, shows a southbound Yellow Car. Also note that although there are some early day autos, horse-drawn wagons are still very much in use. (Courtesy Metro Library.)

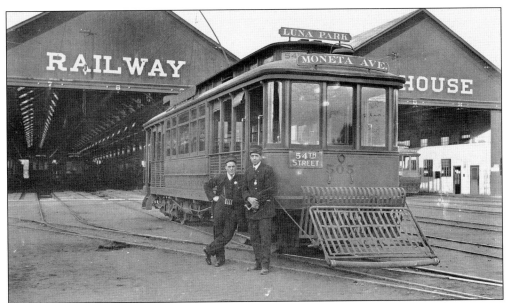

Car No. 505 is ready to leave the Division Two car house, by old South Park Shops at Fifty-fourth and San Pedro Streets, in 1910. Before May 9, 1920, the Yellow Car lines used destinations rather than letters or numbers. The Fifty-fourth Street service would be part of the M Line in 1920, which had many branches. Moneta Avenue is now South Broadway; Luna Park was at Main Street and Washington Boulevard from 1900 to 1912. (Courtesy Craig Rasmussen collection.)

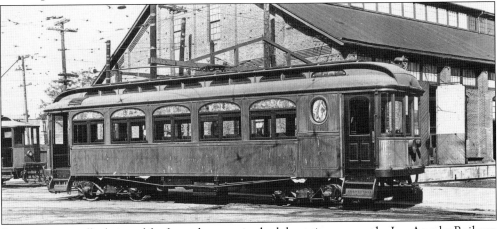

Streetcars specially designed for funeral car service had short-time use on the Los Angeles Railway. These went from the funeral to the cemetery, carrying the departed's coffin up front and mourners behind. Descanso (Spanish for "peace" or "rest") entered service as Paraiso (Spanish for "paradise") in 1909. A second, larger Descanso was built in 1911, and the smaller car (Descanso) became the spare of the pair and the larger car was named Paraiso. By 1921, funeral cars were being replaced by automotive hearses, and the larger car emerged from South Park Shops on January 1, 1922, rebuilt into regular streetcar No. 1101. It retained its original appearance and many would not ride it because of its deathly heritage, so back into South Park Shops it went. It emerged drastically altered as No. 950. The smaller car went into, fittingly, dead storage. In 1939, it was sold to the Pacific Railroad Society, which transported it to the railroad summit of Cajon Pass. In 1967, it was moved to the Orange Empire Railway Museum at Perris, California, where Descanso holds forth to this day. (Courtesy author collection.)

Bedecked as an illuminated float for an electrical night parade in downtown Los Angeles in 1903, a cut-down former Los Angeles Railway passenger car used the direct-current wires above for power, both to propel and light the car. The event was La Fiesta de Las Flores, a flower festival and parade held in Los Angeles beginning in 1894 and continuing through the first decade of the 20th century, although it wasn't an annual event. The extravaganza had various revivals in later years. (Courtesy author collection.)

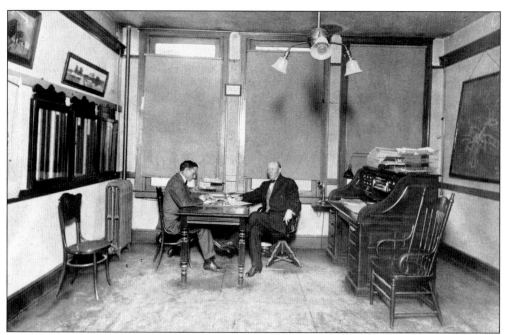

Edwin L. Lewis, who had a longtime career with the Los Angeles Railway and chronicled its history, is seen at his desk in 1909, dictating from his swivel chair to secretary Claud Buchanan. (Courtesy Metro Library.)

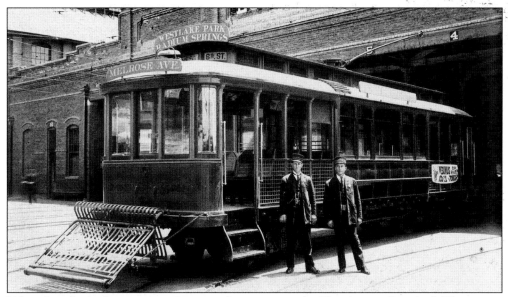

If Los Angeles had a signature streetcar design, it was the Huntington Standard. These were wood-and-steel cars with five-window ends, curved corner windows, and open-end sections that had wooden seats or benches in various configurations. No. 257 had two 50-horsepower motors, was received in 1902, and was scrapped in 1931. It poses with the motorman and conductor in front of Division One carbarn on May 25, 1909. Note that Radium Springs, advertised as a destination on the roof sign, was near Melrose Avenue and Gower Street in Hollywood. (Courtesy Metro Library.)

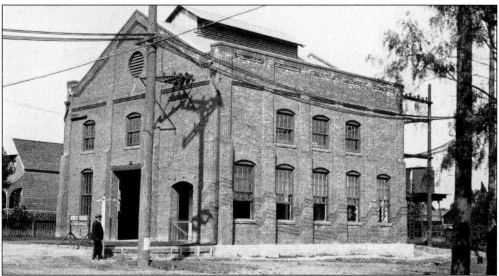

As the Los Angeles Railway streetcar system grew, its power needs went beyond the generating capacity of the central power plant at Sixth Street and Central Avenue. Electric substations began to appear at different locations in 1903. In 1910, this brick substation opened at Soto and Sixth Streets in Boyle Heights. The difference between a station and a substation is that a station would contain power-generating machinery, whereas the substation received high-voltage alternate current (AC) produced elsewhere and converted it into 600 volts of direct current (DC) to feed the trolley wires that provided electricity, via trolley poles, to the car. (Courtesy Metro Library.)

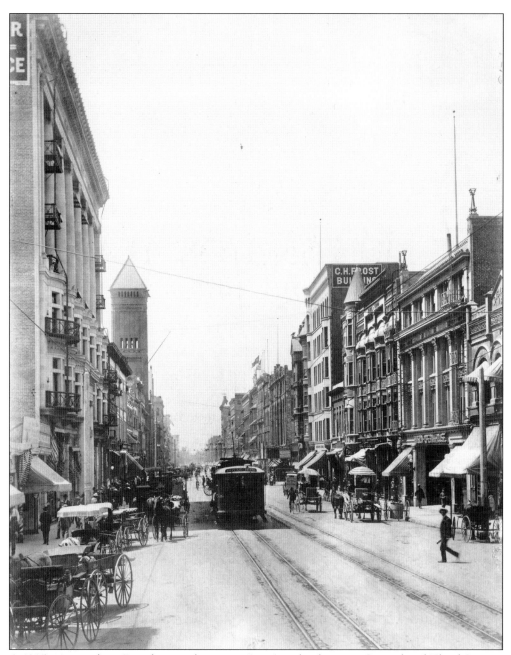

A 1905 view south on Broadway in downtown Los Angeles, between Second and Third Streets, features one of the Yellow Cars bound for Boyle Heights in East Los Angeles. Note that the passenger and freight vehicles are all horse drawn. The tower at left is part of Los Angeles City Hall, replaced in 1928 by the present edifice in downtown. (Courtesy Metro Library.)

Three

THE HUNTINGTON YEARS II
1910–1927

By 1910, Henry E. Huntington had become principal owner of most of the electric railways in Los Angeles, Orange, Riverside, and San Bernardino Counties. He had invested in power and land. But he was over 60 years old, and his main interests had turned to books and art. He sold most of his transportation holdings to the Southern Pacific Railroad, but kept the Los Angeles Railway.

Pacific Electric, by now a Southern Pacific subsidiary, ran the longer lines, and LARY retained most local lines north of 116th Street in Los Angeles. Notable exceptions included the line south to Inglewood and Hawthorne. But Huntington was, in general, out of the interurban business.

In 1912, the Southern Pacific assembled its acquisitions from Huntington, plus a few it already controlled, and formed a new Pacific Electric. Huntington kept Los Angeles Railway, which ran 836 cars on 173 miles of track. These cars and lines included those of the former rival Los Angeles Traction Company, which had been sold to SP in 1904, which in turn passed it over to LARY in the purchase.

A crisis plagued LARY in 1914, when individually owned automobiles and buses, with low fares and frequent service, "stole" potential riders. These "jitneys" (named for a "jit," slang for a nickel) also operated in other western cities, cutting into streetcar revenues. But voters in a 1917 election passed a city ordinance banning jitneys from designated business centers, and they faded away. The LARY system experienced a major rerouting on May 9, 1920, and letter or number designations replaced geographical labels. As well, modernizing took place as 250 steel cars were added to the fleet in the 1920s, and many older wooden cars were retired. South Park Shops also built 60 look-alike—but wooden bodied—cars to match their new steel ones.

Another noteworthy event in the 1920s was the first bus line. When LARY and the Pacific Electric Red Car lines were threatened with competition from a proposed new carrier using double-deck buses, the two companies formed a jointly operated outfit—the Los Angeles Motor Bus Company. Soon after this, the term "bus" was changed to the more elegant term "motor coach."

Henry E. Huntington died on September 26, 1927.

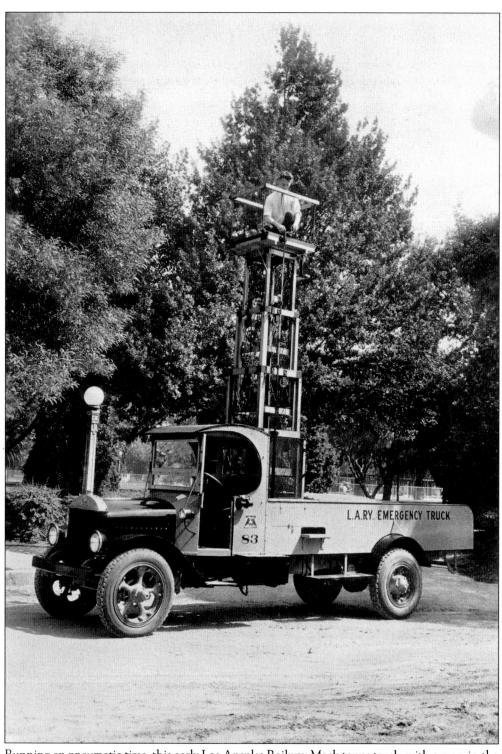

Running on pneumatic tires, this early Los Angeles Railway Mack tower truck, with a man in the tower and its mechanism fully extended, poses for an official portrait. (Courtesy Metro Library.)

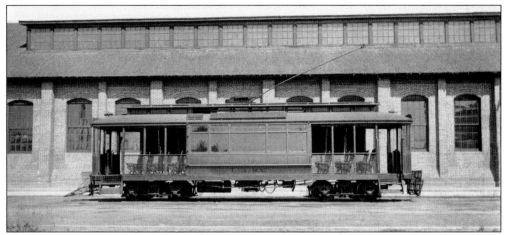

This is an example of an "unlengthened" car, meaning it is as originally built. There were a total of 747 Type B (Standards), of which 250 were built as "pay as you enter" (PAYE) cars. Los Angeles Railway had adopted the PAYE system, and those cars were "lengthened" to 44 feet, 7 inches long, whereas the unmodified Standards continued to be 39 feet long. Rebuilding the shorter cars added about 5.5-feet to each end, and a second rear doorway was added to accommodate boarding riders. The previously "roving" conductor instead stood at the rear, collecting fares as passengers boarded. The forward door at the rear was used by exiting passengers. A half-panel was installed to partition it from the rearmost door. Exiting passengers also used the door at the front of the car. No. 484, posing at South Park Shops, was not lengthened into a PAYE car until 1921. The rebuilding also included the addition of solid panels in the open sections. It entered dead storage in 1925 and was dismantled in 1931. (Courtesy author collection.)

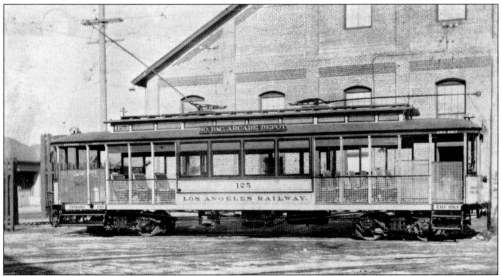

This is an example of a lengthened car. Originally built as Car No. 16 of the Main Street and Agricultural Park Railroad Company in 1896, Los Angeles Railway No. 125 became the first PAYE Standard in 1910. Its appearance is utterly changed from the image on page 12 of the same series. Doors later replaced gates, and the mesh on the sides of end sections gave way to solid panels. Note the four windows in the center section. The car is seen at South Park Shops about 1911; it was scrapped in 1931. Many older-type cars were rebuilt into Standards. (Courtesy author collection.)

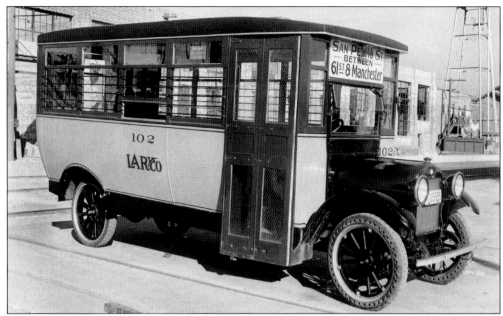

The bus became part of the Los Angeles Railway landscape as the first two arrived in 1922 for the initial LARY bus line along San Pedro Street from Sixty-first to Manchester Streets. Nos. 101 and 102 were built by Reo Motors in 1922. Reo was named after auto pioneer Ransom E. Olds, as was the Oldsmobile. Bus No. 102 is brand new in this image at South Park Shops that year. Note the "LARY" logo on the side. This logo was only used on factory paint jobs for these early buses and for Birney Safety Cars. It disappeared with repaintings, replaced by "Los Angeles Railway" or nothing at all to denote the company. (Courtesy author collection.)

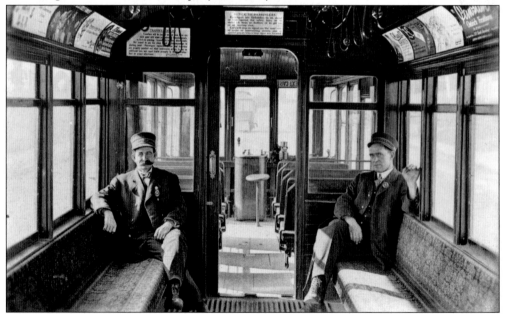

A streetcar crew takes a break inside a Huntington Standard in 1911. Note that the benches on which they sit lack padding and are covered with carpet. The light and airy atmosphere almost made up for the hard seating. (Courtesy author collection.)

The LARY president, Henry Edwards Huntington, sporting the large mustache, enjoys an athletic event at an employee outing in 1913. At his left, in the derby, is his secretary. (Courtesy Metro Library.)

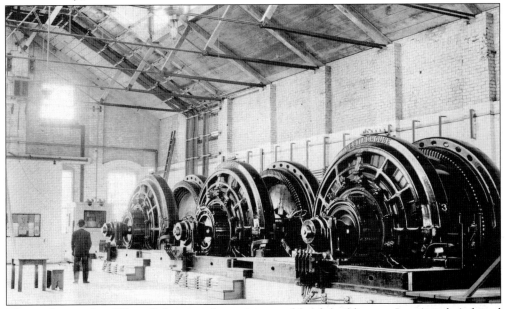

This is the inside of Plaza Substation, housed in a red brick building on Los Angeles's famed Olvera Street. This 1913 view shows three large motor-generator sets (usually only one or two were running) converting imported AC into 600-volt DC units that were fed to overhead wires. This plant was in service until 1962, and the building still exists. Plaza, constructed in 1903, was one of the first three substations on the LARY. (Courtesy Metro Library.)

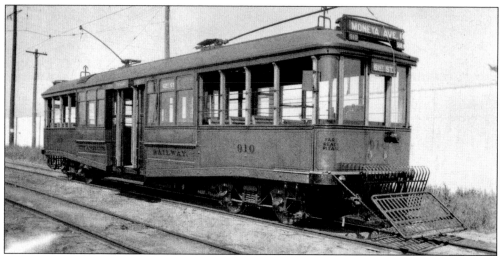

This center-entrance type streetcar, given the inelegant nickname "Sowbelly" because of its under-slung profile "midships," was the result of the hobble-skirt craze, which required lower entrances for ladies. The first center-entrance car appeared for testing on November 7, 1912, and after being blessed by various municipal officials and commissions, entered service January 19, 1913. Seventy-six of these streetcars were built new, and 183 were rebuilt from older cars. The company intended to rebuild all its 700-plus Standards into Sowbellies, but two things occurred to change plans: the hobble-skirt fad faded after only two-plus years, and the jitney bus saga caused huge financial losses. The center-entrance design had one fatal flaw—it took two to run it. This ensured its early retirement. No. 910, built in 1912 as a Sowbelly, ran until 1945, when it went to scrap. (Courtesy author collection.)

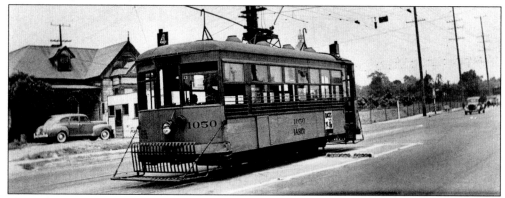

Playing a minor role on LARY was the little Birney Safety Car, named after Charles O. Birney, master mechanic of the Stone and Webster Engineering Firm. The car came into the LARY system in 1920 and 1921. The term "safety" referred to interlocks in the controls, which prevented operation when doors were open and brought the car to a quick stop if the motorman was incapacitated and let go of the controls. There were 70 of these Type G cars, but many were placed in dead storage in the 1920s. Only a dozen of the tiny cars were operated at one time in later years. Four became work cars, and all were retired by 1946. The Birneys required only one crew member. They were fitted with specially designed external fenders to comply with a city ordinance. Car No. 1050 is seen between runs on Boyle Avenue at Seventh Street on the Boyle Avenue shuttle, which ran south to Olympic Boulevard as the 4 Line from 1939 to 1941. Note that it still has its car-builder paint job; the Birneys were the only streetcar type sporting the "LARY" logo, which disappeared in subsequent repaintings. (Courtesy Craig Rasmussen collection.)

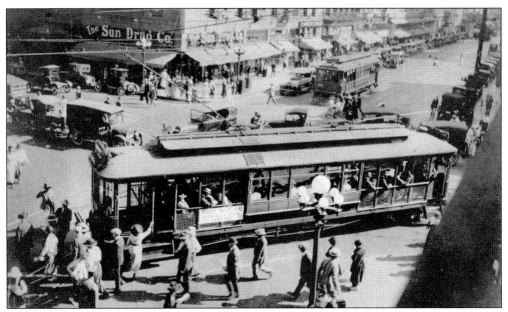

Downtown Los Angeles is depicted in 1919 at the corner of Seventh Street and Broadway—the downtown intersection of the day. The Boyle Heights and West Seventh Street Line had two termini at its western end, the other at Normandie and Melrose Avenues. The assignment of letters and numbers to lines occurred the following year. The full route of the segment of this line was from Gage and Wabash Avenues, down Gage, on Hammel Street to Rowan Avenue, Rowan to First Street, then on Broadway, Seventh Street, Alvarado Street, Hoover Street, Wilshire Boulevard, Commonwealth Avenue, Sixth Street, Vermont Avenue, Third Street, and Western Avenue to Melrose Avenue. (Courtesy Metro Library.)

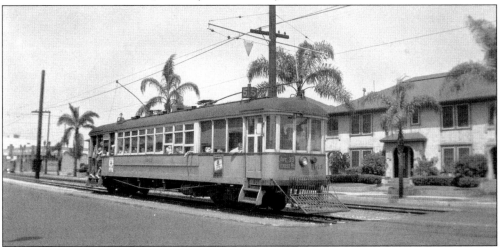

The Type Fs, the sixteen 1100s, were produced by cutting Type A (35 feet, 5 inches long) streetcars in half and lengthening the center sections by inserting an extension, resulting in a 48-foot-long car with all cross seats (56 versus 34 before). Additionally, they were capable of multiple-unit operation. Car No. 1155 had been a Type A 13, emerging from South Park Shops on August 18, 1922. It was a bit more than a year later when the other 15 Fs were released. No photograph seems to exist of the rare train operation of the 1100s. This c. 1940 view shows No. 1153 operating on the 5 Line, bound for its north terminus. (Courtesy Craig Rasmussen collection.)

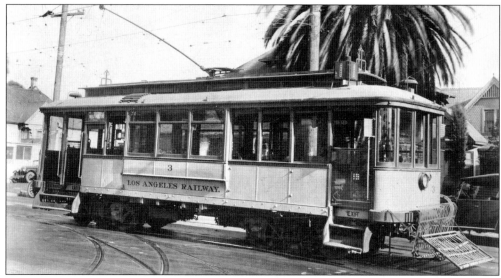

Many older-style streetcars were rebuilt into a short (35 feet, 5 inches long versus 44 feet, 7 inches long) version of the Huntington Standard. They were later known as Type A. Some of these cars had magnetic brakes. When a special controller was engaged, shoes in the trucks between the axles grasped the top of the rail. These cars were dubbed "Maggies" or "Shorties." Originally there were 45 Type A cars, but many were rebuilt into Type C center-entrance cars during the 1910s hobble-skirt craze, and 16 of the little cars became long, Type F streetcars. This left only eight Type A cars, and all were retired in 1939 when the I Line was converted to buses. (Courtesy author collection.)

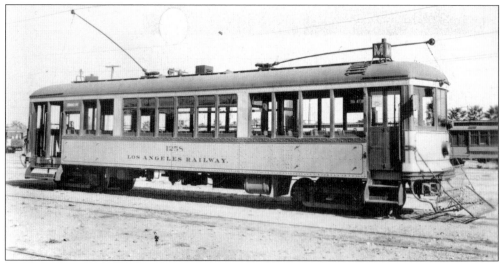

Los Angeles Railway entered the steel streetcar era with the delivery of the first batch of Type H cars in 1921. Altogether there would be 250 built, and the last was delivered in 1924. Later orders of Type H cars had variations in equipment, and they lasted into the 1950s. These cars had the typical "California" open-closed combination sections, but with a newer control system, a steel car body, and arch-design roof. Although equipped for multiple-unit operation, this feature had difficulties. Train operation, by use of a jumper cable between cars to make it unnecessary to have the pole up on the second car, ended in 1930. Car No. 1258, signed for the M Line, sits behind the Division Five car house in the early 1920s. (Courtesy author collection.)

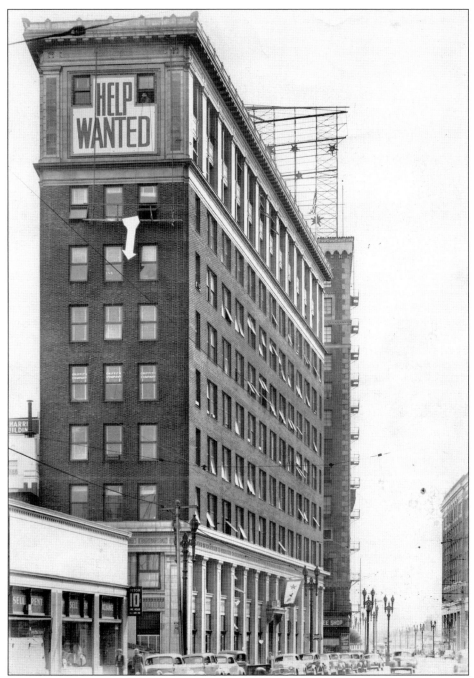

After sharing quarters with Southern Pacific–owned Pacific Electric Railway since 1910 at its Sixth and Main headquarters building, Los Angeles Railway moved into its own new building at the northeast corner of Eleventh Street and Broadway in May 1921. This view of the building, looking southeast, was taken during World War II (note the caps atop streetlights to prevent light shining into the sky, which would provide a navigational aid to enemy planes). Prominent on the building is a large "Help Wanted" sign to recruit operators for the streetcars and buses to replace regulars who had gone into the military during World War II. (Courtesy Metro Library.)

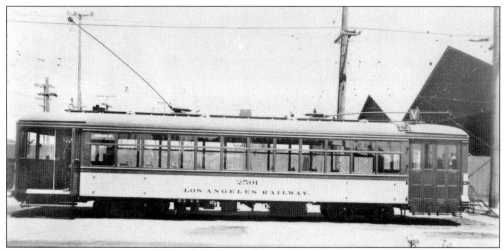

Car No. 2501, Type L, was a one-of-a-kind test bed for many innovations, including a pair of trucks with 26-inch wheels, instead of 30-inch wheels, which gave the car's interior a lower floor to make boarding and exiting easier. It was equipped with variable load brakes, which literally weighed passengers and adjusted themselves accordingly. This mechanism was a source of trouble, and it was disconnected in 1926. Like all previous streetcars on LARY, Car No. 2501 was double-ended, meaning it had controls at each end. But it was too far ahead of its time, so the type was limited to the one car. (Courtesy Metro Library.)

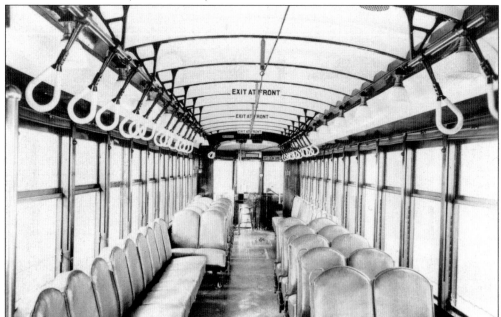

Inside this lone Type L, a solid bulkhead to form a partition for both ends is missing. The car was delivered with the usual hard, wood seats and benches; a 1928 overhaul replaced them with much more comfortable upholstered seats. Among some features new to Yellow Car riders were stirrups for standees, as well as glazed windows for all passengers. In 1927, external folding steps were removed and the doors lengthened. Car No. 2501's trucks were closer together than on other LARY streetcars, causing a long overhang. For most of its service life, it was assigned to the 7 Line, which had few curves. (Courtesy Metro Library.)

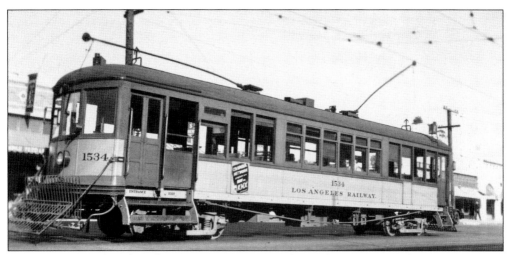

Type K cars, numbered in the 1500s, were Los Angeles Railway copies of the Type H. LARY announced that it would produce 82 of them, but only 60 were built at South Park Shops between 1923 and 1925. Outwardly identical to the H cars, their wood-body construction was belied by truss rods. After the 1955 conversion, 59 went to scrap and lucky No. 1559 now finds itself at the Orange Empire Railway Museum in Perris, California. In this 1936 view, Car No. 1534 is at the York Boulevard and Avenue 50 Terminal of the W Line. (Courtesy author collection.)

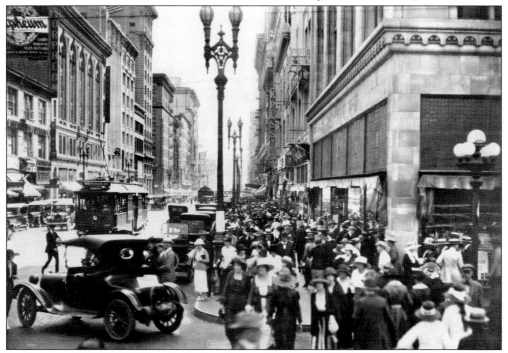

Looking south on Broadway at Sixth Street in the late 1910s, the sidewalks are full of pedestrians and a center-entrance Sowbelly Los Angeles Railway car heads south on the principal downtown shopping thoroughfare. At left is the third home for the Orpheum Theatre, built in 1911 and renamed the Palace in 1926. The fourth (present) home for the Orpheum is on the east side of Broadway near Eighth Street. The Palace closed in the 1990s. Its interior is still intact and is used as a location for movie and television filming. (Courtesy Metro Library.)

Los Angeles Railway's Division Five, near Crenshaw Boulevard and Fifty-fourth Street, opened in October 1912 to serve an expanding streetcar system in the city's southwest corner. This 1920s view looks south to the concrete car houses. The building at left is Substation O, Division Five, which opened in 1924. Buses were later added to the division and took it over completely on May 22, 1955. (Courtesy Metro Library.)

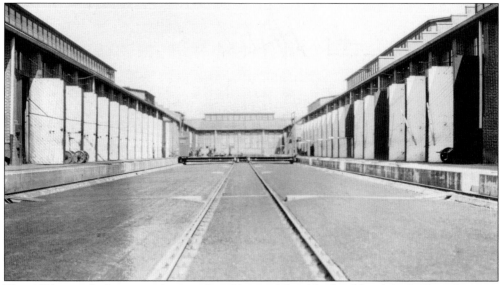

This 1920s view looks east to the transfer table pit of the old side of South Park Shops between Fifty-third and Fifty-fourth Streets on the west side of Avalon Boulevard (formerly South Park Street). The shops were completed in 1906. The function of the transfer table was to move rolling stock sideways to a bay where repair or maintenance would be carried out. The buildings on the old side were constructed of red brick. This portion of South Park Shops was closed in 1946, and Los Angeles Transit Lines sold the property because of "efficiency." Many of the jobs that had been done in-house now had to be sent out, causing maintenance costs to soar. (Courtesy Metro Libary.)

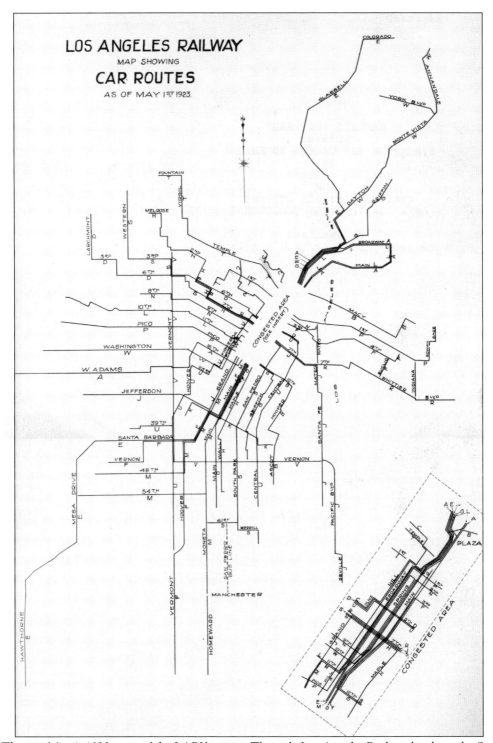

This is a May 1, 1923, map of the LARY system. The only Los Angeles Railway bus line, the San Pedro Street route, is shown on the south part of the map in the vicinity of the S Line. (Courtesy Metro Library.)

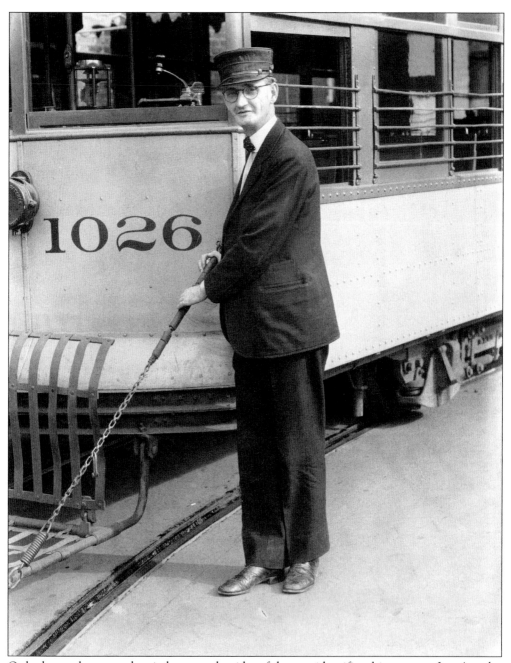

Only the employee number, in brass on the sides of the cap, identifies this man as a Los Angeles Railway employee. He stands by one of the Type G Birney Safety Cars around 1920. He served as both motorman and conductor, since the Birneys ran with single-man crews. (Courtesy Metro Library.)

Four

THE LATER LOS ANGELES RAILWAY YEARS
1927–1945

After Henry Huntington's death in 1927, his estate continued to run the Los Angeles Railway. The management team he had assembled did a fine job continuing to keep the Yellow Car network, which was still mostly a rail concern, going in high gear. After all, this was the Roaring Twenties.

But cracks in the operation were beginning to show. More riders switched to their own automobiles as more paved streets and highways became a real lure. More residents dispersed to suburbs further out, and this resulted in further loss of patronage. Both single- and double-deck buses were taking over some of the marginal rail lines and being used on new routes, which were thoroughfares that had never experienced streetcars.

LARY continued to study streetcar improvements and ordered two Type M cars (Nos. 2601 and 2602) that were delivered in 1930. By the time they were built and shipped by the St. Louis Car Company—one with Westinghouse equipment and the other with General Electric components—the Great Depression had hit, and no more Type Ms were ordered. By the time the economy was recovering, a new type of streetcar, the PCC Streamliner, had taken the spotlight.

The 1930s created hard times for everyone; this was particularly so for the Los Angeles Railway. Ridership declined as unemployment rose, so the line tightened its belt and hoped to ride out the economic slump. Labor troubles began as the federal government introduced laws resulting in the LARY's first unionizing (collective bargaining), much to the dismay of management. The 1937 delivery of the first batch of PCC streetcars, or "Streamliners," brought with it optimism for the future. Buses also assumed a larger role in the LARY system.

War clouds gathered in the 1930s in Europe and Asia. This brought increased industrial activity for Los Angeles and a rise in patronage. Entry of the United States into what became World War II brought ridership increases due to gasoline rationing. But military needs foreclosed building or fueling public transportation vehicles. So LARY had to limp along for "the duration."

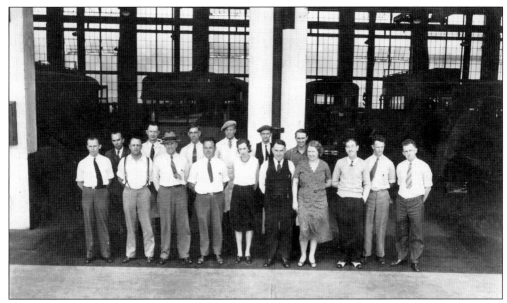

A group of workers at the Los Angeles Railway's Sixteenth Street Garage (later Division Two) poses in front of some of the garage bays in 1931. (Courtesy Metro Library.)

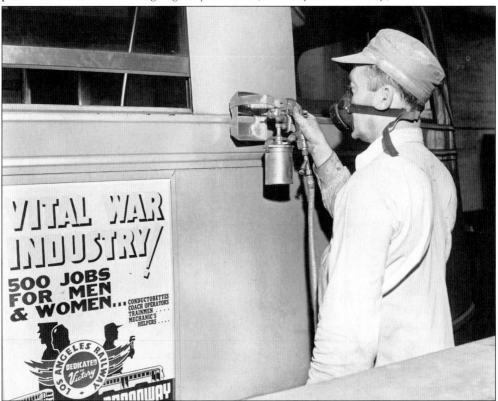

At South Park Shops, a Los Angeles Railway painter goes over the belt rail of a PCC Streamliner during World War II. Note the advertisement sign seeking staff due to the shortage of manpower created by the needs of World War II. (Courtesy Metro Library.)

The new portion of South Park Shops was on the west side of Avalon Boulevard between Fifty-fourth and Fifty-fifth Streets. Part of it is in this eastward look from the transfer table pit in the 1920s. The transfer table was built in 1910 and was last used in the summer of 1962, when the pit was filled in and the table was cut up. (Courtesy Metro Library.)

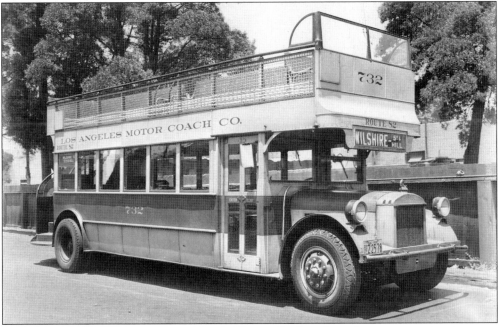

In 1923, the Los Angeles Railway and Pacific Electric Railway formed a joint operating company, the Los Angeles Motor Bus Company (LAMB), to forestall bus-service competition. It was later renamed the Los Angeles Motor Coach Company (LAMC). LAMC buses were stored at LARY Division Five until completion of LAMC's own offices and yard at Virgil Avenue and Santa Monica Boulevard in 1926. Double-decker bus No. 732, seen at the Virgil Avenue Yard in 1938, was built by Fageol in 1926. Similar open-top, double-deck vehicles were purchased by LARY in the 1920s. (Courtesy Metro Library.)

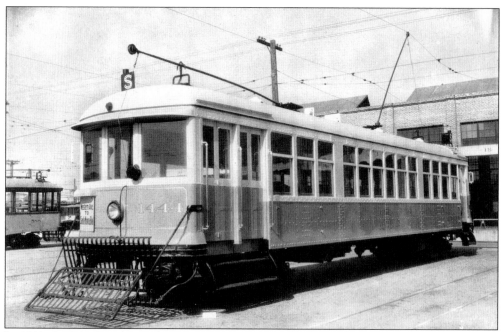

In 1929, the Los Angeles Railway sent Type H cars 1416–1450 to South Park Shops, and they emerged as deluxe streetcars. The two most noticeable features were upholstered seats and end sections enclosed with glazed window sashes. One of the reasons for all this was a fare raise in 1928 from a 5¢ to 7¢. The cars also received a special livery that was painted green and cream and had a silver roof and a special mid-car logo with "LARY" spelled out with the car number in the center—all inside an oval—as well as lettering and striping in gold. The special livery was soon replaced by a standard LARY livery as the green cars went through the shops. Car No. 1444, which was the first of the H-3 cars, poses at South Park Shops in August 1929. (Courtesy author collection.)

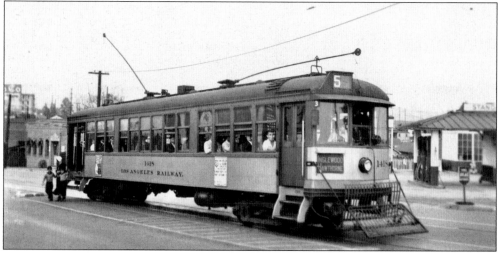

Car No. 1418 heads for the end of the 5 Line in Hawthorne in 1936 after being repainted at South Park Shops in the sedate LARY colors of yellow and brown. It is at Bridge Junction where car lines split and some go over the Los Angeles River on the Spring Street span and other routes proceed over the former Buena Vista (now Broadway) Viaduct. (Courtesy author collection.)

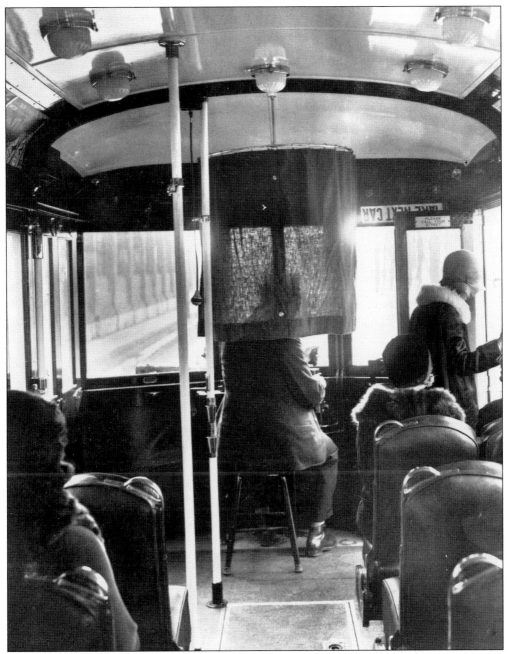

This is a publicity photograph taken on Fifty-fourth Street alongside South Park Shops in 1930 to show some of the features of the just-released deluxe Type H-3 streetcar. The first item one notices is upholstered seats, which was a real improvement over hard wooden seating. The curtain was normally drawn at night to prevent interior lights from reflecting on the motorman's window, thereby creating a hazard. (Courtesy Metro Library.)

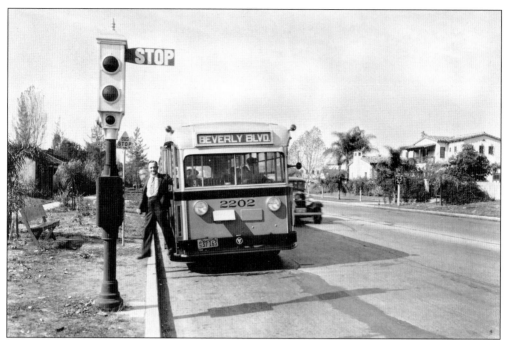

West of downtown, some streets did not have streetcar tracks like this section of Beverly Boulevard where this publicity photograph was taken at a bus stop. Notice the sign, similar to a triangle-like streetcar stop, pointing up instead of down. Note also an icon of long-ago Los Angeles, an Acme semaphore traffic signal. The bus was built by Yellow Coach as part of a batch of five in 1934. (Courtesy Metro Library.)

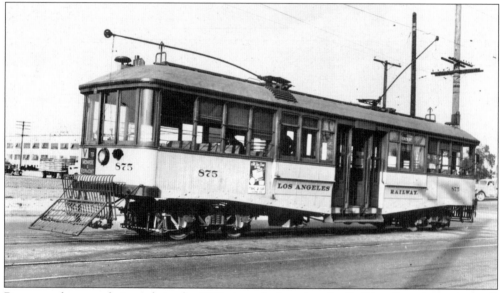

Buses may have made inroads in the 1930s into the Los Angeles Railway fleet, but it was still predominately a streetcar operation. Seen here is a Sowbelly-type, center-entrance car, No. 875, at the Leonis Boulevard and Downey Road end of the V Line, ready to return via Vernon and Vermont Avenues to Monroe Street, the site of Los Angeles City College (and UCLA from 1919 to 1929). (Courtesy author collection.)

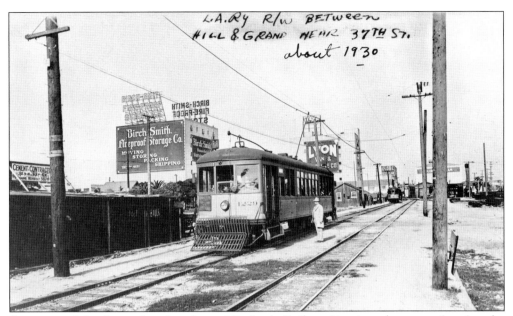

A portion of the former Los Angeles and Redondo Railway Line into downtown Los Angeles became part of LARY when the line was split in the sale of many Huntington rail properties to Southern Pacific in 1910. This *c.* 1930 view shows car No. 1229 on the M Line on a right-of-way paralleling Grand Avenue, near Thirty-seventh Street, headed for its Hawthorne Terminal. (Courtesy Craig Rasmussen collection.)

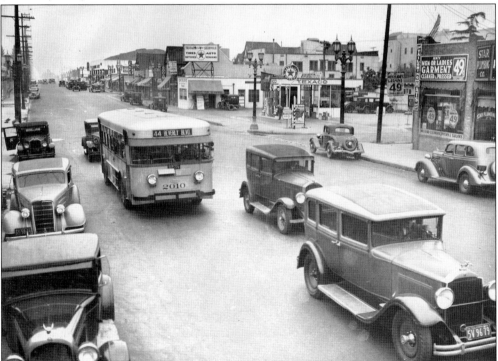

Running along Beverly Boulevard near Normandie Avenue in 1935 is Bus No. 2010, a product of Twin Coach. Trademark enthusiasts may find objects of interest in this shot. (Courtesy Metro Library.)

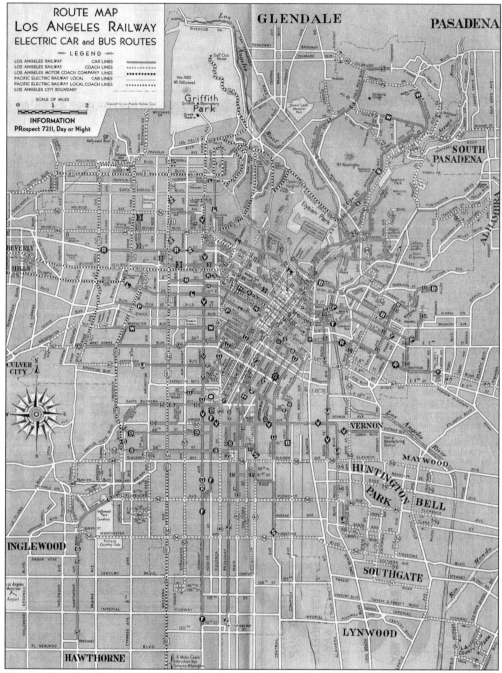

This is the official route map of the Los Angeles Railway as of April 1, 1935. It also shows the routes in the area of Pacific Electric Railway Red Cars and the joint LARY/PE Los Angeles Motor Coach Company. The downtown detail map is on page 49. (Courtesy author collection.)

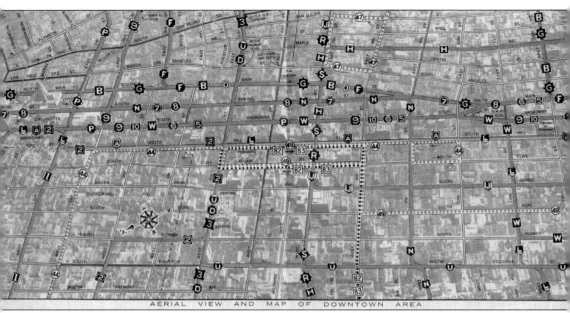

This 1935 map shows the downtown Los Angeles routes. (Courtesy author collection.)

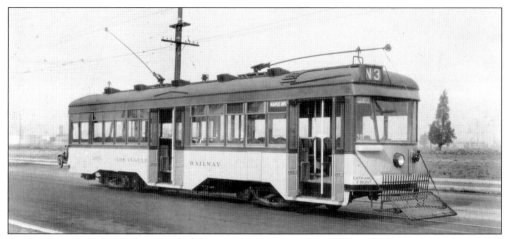

In 1930, Los Angeles Railway took delivery of two cars—Nos. 2601 and 2602—dubbed Type M. Car No. 2601 was equipped with Westinghouse control equipment while No. 2602's components were from General Electric. Both cars had improvements in their controls and other appliances. A big change from previous practice was upholstered seats. The two cars were ordered from St. Louis in 1929 before the economic downturn. Had the Depression not hit, many more Type Ms would have joined the fleet. But by the time some recovery occurred in the mid-1930s, a streamlined streetcar had the spotlight. This three-quarter view of No. 2601, an official LARY photograph, shows the external fender, the "people-" or "cow-catcher," mandated by city ordinance. (Courtesy author collection.)

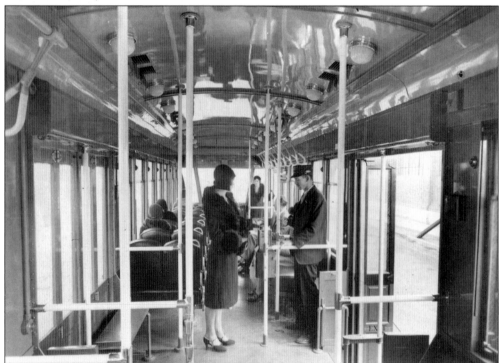

Los Angeles Railway took this publicity view inside Type M car No. 2601. Note the combination of upholstered front- and side-facing seating and the enameled metal straphangers. (Courtesy author collection.)

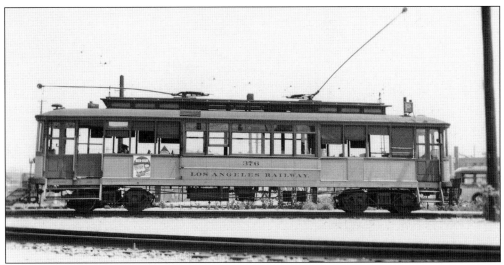

One of Los Angeles Railway's hundreds of Standards, No. 376, is seen in the 1930s in the Pico and Rimpau Boulevards loop of the P Line. It had been built in 1904 as Car No. 339. The original No. 376 was rebuilt into Sowbelly No. 44 in 1915, and No. 339 became the second No. 376 in 1919. It was sent to scrap with that number in 1949. (Courtesy author collection.)

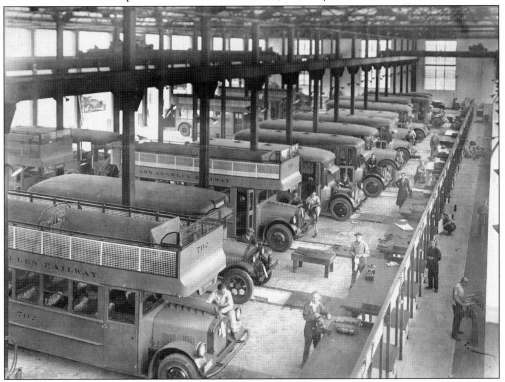

The heart of the Los Angeles Railway's bus operation, which opened around 1923, was the Sixteenth Street Garage just east of San Pedro Street. In 1923, it was raised to full division status, and it became Division Two after the original, alongside South Park Shops, closed on July 31, 1932. Seen here is the main bay of the division in the 1930s with both single- and double-deck buses being maintained or repaired. (Courtesy Metro Library.)

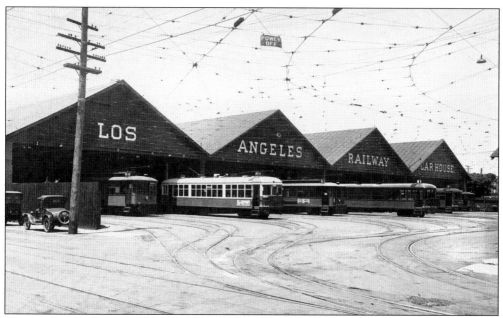

Division Two car house, at Fifty-fourth and San Pedro Streets next to South Park Shops, opened on February 1, 1904. This 1931 view is of its east end and includes one of the green H-3 deluxe cars. One of its five-track bays had an upper floor on its west end. The city grew north and west but not so much around the division, so it closed on July 31, 1932. (Courtesy Metro Library.)

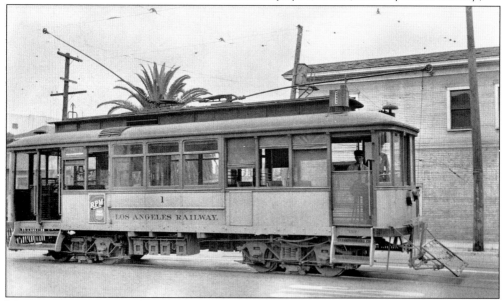

Most streetcar operations had a Car No. 1, and here is Los Angeles's Type A Maggie No. 1 at the First Street and Bonnie Brae Terminal of the I Line, west of downtown, in 1937. It was built in 1897 for the Los Angeles Traction Company. LAT was later bought by Southern Pacific and turned over to Huntington's Pacific Electric. As part of the Great Merger of 1910, the car became the property of Los Angeles Railway as its No. 35. It became No. 1 in 1912 and continued to serve the I Line until the line was converted to buses in 1939. It was scrapped that year. (Courtesy Craig Rasmussen collection.)

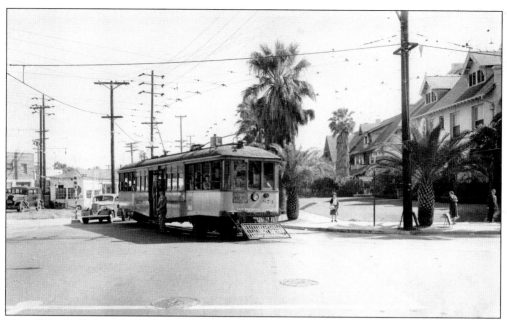

Type C Sowbelly car No. 874 turns from Hoover Street onto Olympic Boulevard in the 1930s en route to the L line's terminus at Olympic and Mullen Avenue, site of Los Angeles High School. (Courtesy author collection.)

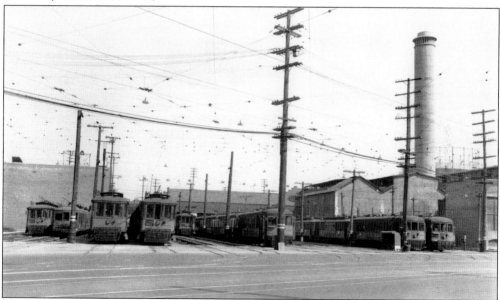

Opened in August 1899, this is Division One at Central Avenue and Sixth Street, which was the oldest of Los Angeles Railway's operating facilities. Originally, the division was inside buildings, but they were demolished over the years, leaving mostly outdoor yards. The giant power plant with the large smokestack at right produced electricity for the system until new lines were built beyond its capabilities. Soon a central power station was replaced by substations receiving power generated by outside sources. This facility began housing buses in the 1940s, including trolley buses in the later years of that decade, and became an all-bus division in 1955. (Courtesy Craig Rasmussen collection.)

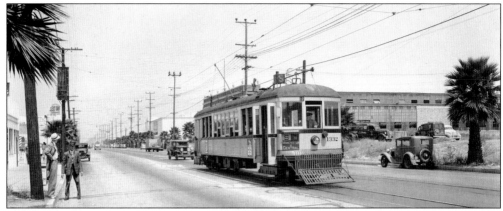

The combination of the economic squeeze of the Great Depression and the general loss of patronage as more former riders used automobiles by the 1930s called for massive reduction of costs for running Los Angeles Railway streetcars. The rebuilding of many of the Type H cars into Type H-4 cars at South Park Shops created units that could be operated either by one man or two (only males had the platform jobs until World War II). Manually operated doors and fixed steps were replaced by air-operated doors with folding steps. Treadles were installed, so patrons could exit without assistance. The alternative, which occurred anyhow, was buses. Beginning in October 1935, a new color scheme was adopted: yellow below windows, a black stripe midway up, aluminum around the windows, and brick red roofs. This livery was applied to many streetcars and buses as they went through the shops. (Courtesy author collection.)

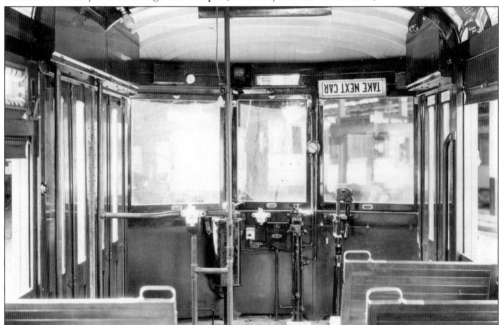

The first H-4 was Car No. 1201. This interior view was taken before a second front door was installed. Other changes included safety equipment with "deadman" control, requiring the operator either to push down on the controller handle or use a foot pedal at its base. If neither were used, the car would go into emergency braking and would not start again until the deadman features were engaged. The H cars lost their couplers in this rebuilding. Multiple-unit operation was troublesome and was rarely used. (Courtesy author collection.)

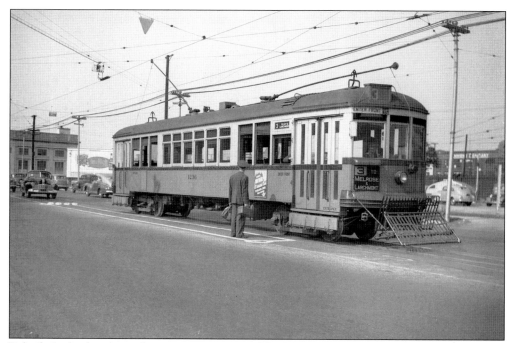

Rebuilt for both one- and two-man operations, H-4 No. 1236 sits at a stop on Central Avenue and Sixth Street near the former Southern Pacific's Central Railroad Station (left) in 1941. By then, Central had been replaced by Los Angeles Union Passenger Terminal. (Courtesy Craig Rasmussen collection.)

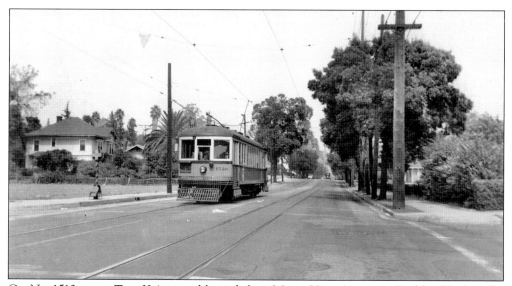

Car No. 1510, now a Type K-4, is southbound along Monte Vista Avenue in Highland Park in the late 1930s. The K cars had gone through the same rebuilding as the H cars, as did some of Type B, all of Type F, Type L, and the two Type M cars. (Courtesy Craig Rasmussen collection.)

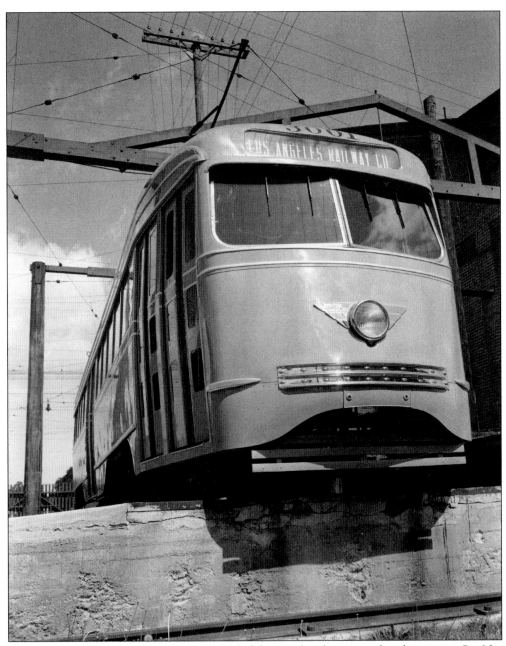

In March 1937, the Los Angeles Railway took delivery of its first streamlined streetcar. Car No. 3001, dubbed by LARY as its Type P, is shown in this dramatic image at South Park Shops with the photographer in the transfer table pit. The features of the Streamliner were developed by the Electric Railway Presidents' Conference Committee, and it was called the PCC. (Courtesy author collection.)

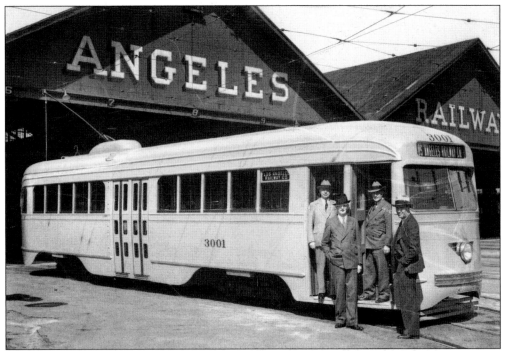

Posing at the former Division Two car house at South Park Shops is a group of proud executives of new owner Los Angeles Railway with the first PCC, Car No. 3001, in 1937. The Streamliner was used on many transit systems with local variations in areas such as seating and door arrangement. (Courtesy Metro Library.)

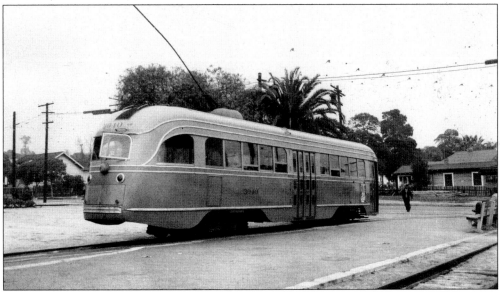

Car No. 3040, at the Dozier and Rowan loop of the P Line, shows the LARY livery for the PCCs: chrome-yellow bottoms and lemon-yellow detail around windows and parts of the roofs. The top (canvas) portion of the roof was painted light gray. Drip rails and extrusions below the windows were enhanced by chrome paint. Bumpers and light holders were chrome plated. The "2B" was a World War II classification. (Courtesy author collection.)

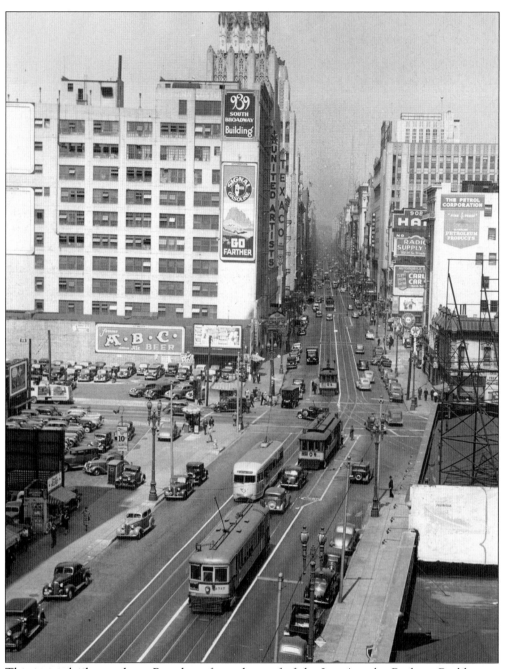

This image looks north on Broadway from the roof of the Los Angeles Railway Building at Eleventh Street in 1938. Streetcars served Broadway's downtown portion exclusively until 1955. This is the same image as on the book's cover. (Courtesy Metro Library.)

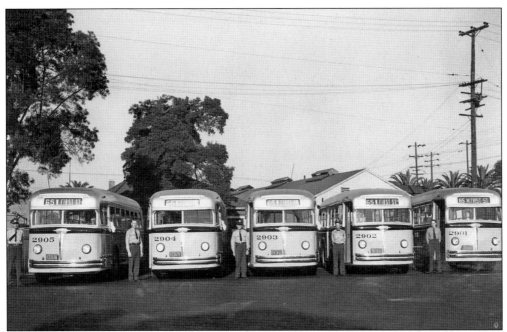

One of Los Angeles Railway's first conversions from streetcar to bus occurred in 1939, when the I Line became Bus Line 65, using this fleet of five White Motors buses. (Courtesy Metro Library.)

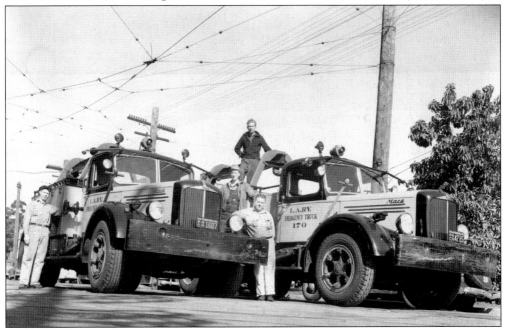

"Rough and ready" would be a good title for this 1942 image of two Mack truck wreckers and crews. Equipped with red lights and sirens, these units would rescue failed streetcars or buses. During World War I, one of Germany's weapons, a railroad howitzer, was called the Big Bertha, and these emergency trucks earned the nickname "Bertha" due to their power and size. One of these trucks rolling down the street, its siren wailing and red lights flashing, was a singular sight. (Courtesy Metro Library.)

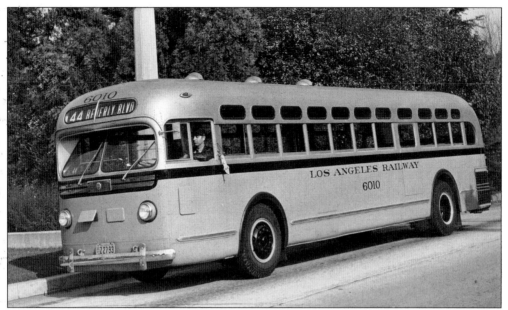

At the close of the 1930s, Los Angeles Railway executives fell in love with the General Motors diesel bus, like this new 45-passenger motor coach, No. 6010, seen at the east end of the Sixth Street viaduct over the Los Angeles River in 1940. This body shell, in different lengths, continued to be produced into the 1950s, as buses replaced many a streetcar. (Courtesy Metro Library.)

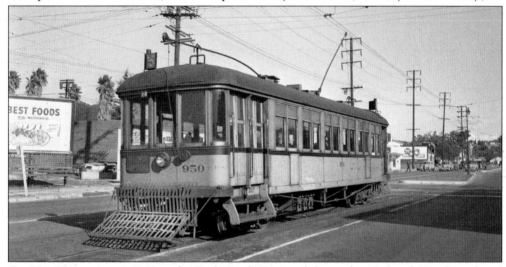

Car No. 950 is seen in 1940 at the Eagle Rock Terminal, located at Colorado Boulevard and Townsend Street, of Los Angeles Railway's longest streetcar line, the 5 Line. The 5's other end was in Hawthorne. It was built at South Park Shops in 1911 as a larger version of funeral car Descanso. The smaller car retained the name Descanso, and the larger car became Paraiso. When the era of taking streetcars to cemeteries was over, it became a regular streetcar in 1921, No. 1101. Riders recognized that it used to be a funeral car and would not ride it. So back to the shops it went for more building. The arches in the upper side sash were replaced by straight-sided sash and the railroad-style deck roof became a more plain arch style. It emerged in 1924 with a new identity, No. 950, and spent its remaining years as a run-of-the-mill car, going to scrap in 1951. (Courtesy Craig Rasmussen collection.)

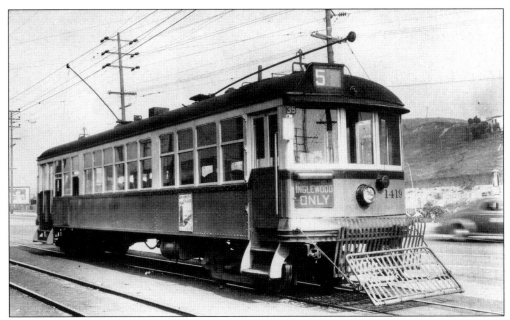

One of the deluxe H-3 cars, No. 1419, is on the long 5 Line in Glassell Park in 1940. These (Nos. 1416–1450) were the last of the H cars to receive new doors, folding steps, treadles, and other equipment for one-man operation. They could only operate as two-man cars, presumably on heavy lines. (Courtesy Craig Rasmussen collection.)

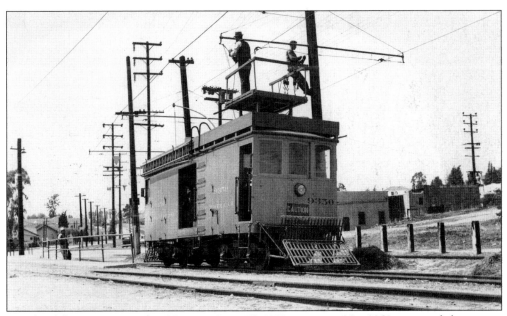

At Glendale Junction on the 5 Line on June 15, 1939, tower car No. 9350 pauses while its crew performs repairs on the overhead wires. Some wag termed these sorts of repairs as "celestial knitting." Note the siding in the foreground, used to turn back "rush-hour trippers," cars that did not go the end of the route. (Courtesy Craig Rasmussen collection.)

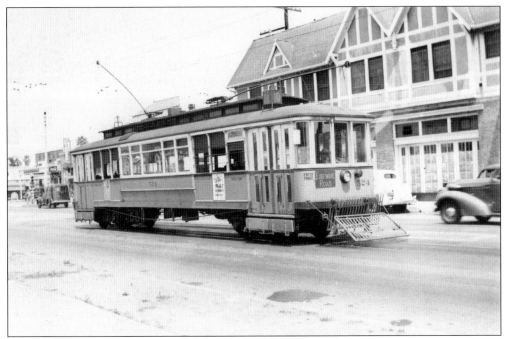

Los Angeles Railway Type B car No. 524, rebuilt for one- or two-man service, is running in the former mode. Note the lettering in the front corner indicating "Enter Front." The location is the Vernon and Arlington Terminal of the 10 Line in 1940. (Courtesy author collection.)

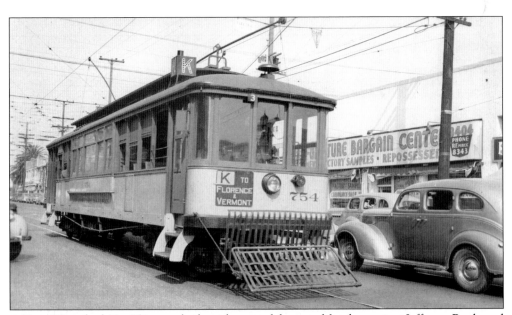

A Type B Standard, No. 754, not rebuilt, with manual doors and fixed steps, is at Jefferson Boulevard and Vermont Avenue on the K Line in 1940. The K Line became Bus Line 18 on October 5, 1941, two months and two days before the Pearl Harbor attack. (Courtesy author collection.)

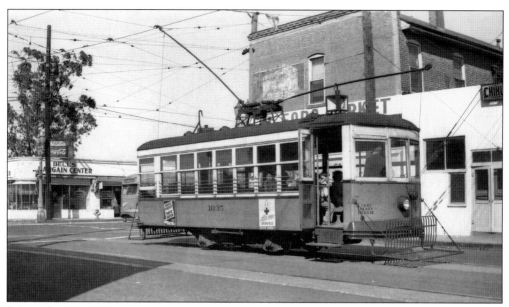

Birney Car No. 1035 awaits passengers on Indiana Street at East First Street. Many of the shuttle car's riders would transfer from P cars. The Indiana shuttle ran on Indiana Street to Whittier Boulevard. (Courtesy Craig Rasmussen collection.)

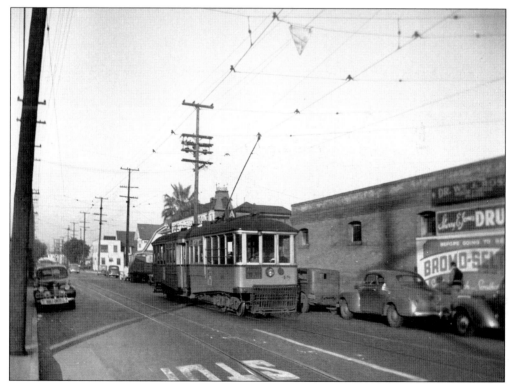

An A Line Sowbelly car, No. 48, is seen here at Temple and Hoover Streets in 1941. (Courtesy Craig Rasmussen collection.)

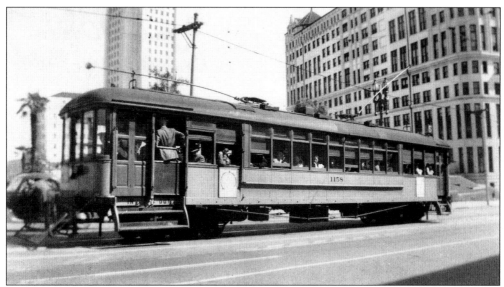

Car No. 1158 is headed north on Broadway in the civic center area during World War II. It has just passed the now-gone Hall of Records. (Courtesy author collection.)

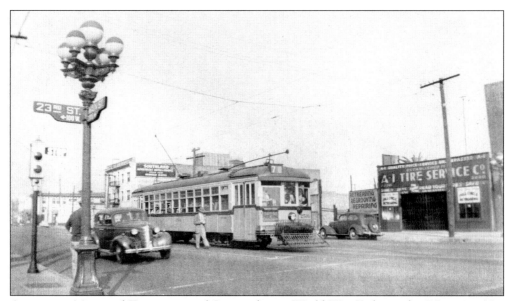

A scene on Main and Twenty-second Streets during World War II shows the 7 Line car No. 2501 heading toward its 116th Street and Broadway Terminal. Note that the tops of the globes on the candelabra streetlights are painted over. This was a wartime measure. (Courtesy author collection.)

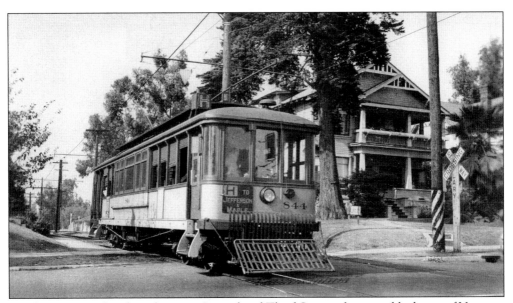

On the H Line right-of-way between Second and Third Streets, from one block east of Vermont Avenue to Rampart Boulevard, Car No. 844 crosses one of many streets in this residential neighborhood. The time is October 1942. (Courtesy author collection.)

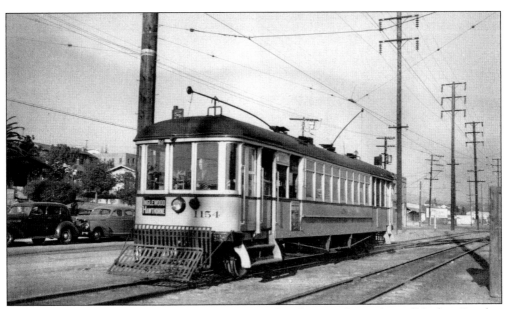

Homebuilt Car No. 1154 runs on the 5 Line on a right-of-way in the median of Verdugo Road in 1942. (Courtesy author collection.)

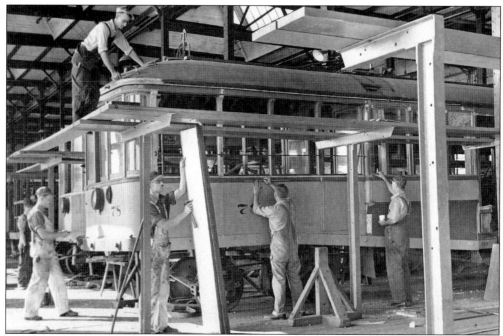

The South Park Shops forces kept streetcars running during World War II, as seen here in a view of the carpentry area. (Courtesy Metro Library.)

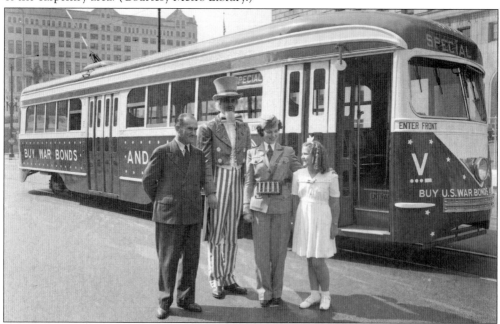

Streamliner PCC No. 3010 is shown on Spring Street between First and Temple Streets, posing for a war bonds promotion. People standing in the foreground include "Uncle Sam" and a "motormanette." Labor shortages caused by so many male employees going into the military brought about the hiring en masse of females as platform (on-board) staff. Los Angeles Railway also hired minorities as platform workers for the first time. Behind at left is the now-gone Hall of Records, and at right is the Hall of Justice. (Courtesy Metro Library.)

Division Four is seen from a company tower truck in this is wartime view on Georgia Street. The street crossing from left to right is Twelfth Street. In the distance is a small shop building on Twelfth Place. All of this, including the streets, is now gone and is the site of the Los Angeles Convention Center and Staples Center. (Courtesy Metro Library.)

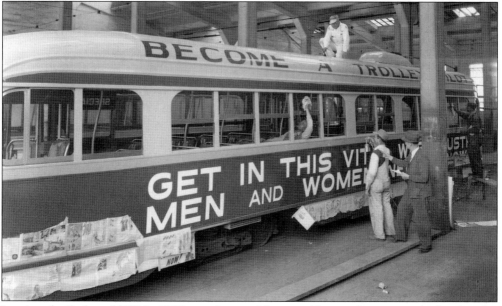

Los Angeles Railway PCC No. 3010 was often used for special liveries. It is seen at the Los Angeles Union Passenger Terminal loop at Alameda and Macy Streets in 1943. To entice people to become "trolley pilots" (a home-front streetcar operator), the company used very bright publicity colors on some of their streetcars. (Courtesy author collection.)

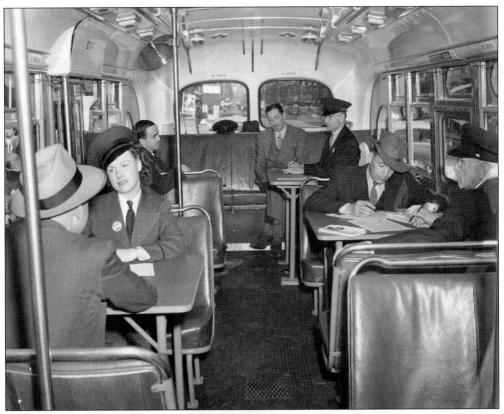

During World War II, Los Angeles Railway suffered a shortage of motormen, conductors, and bus drivers. Its male employee ranks were decimated because many joined the military. So, Bus No. 6511 was reconfigured as a mobile employment office. Wartime brought the hiring of female and non-Caucasians as platform workers, many of whom kept their jobs after the war. (Courtesy Metro Library.)

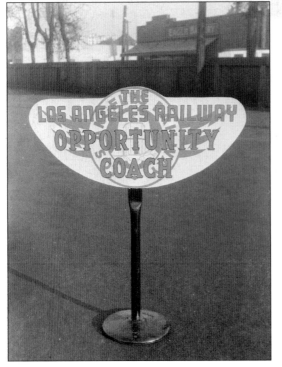

To publicize its "Opportunity Motor Coach," LARY would post this colorful sign by the front door. Note the Mission Bell logo beneath the lettering. (Courtesy Metro Library.)

This is an interior view of the front end of a Streamliner PCC streetcar. (Courtesy author collection.)

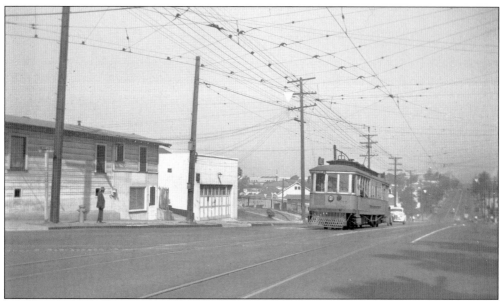

Car No. 517 is on the E (Euclid) Line during the war. It serviced the City Terrace end of the B Line, except for rush hours. The E Line fell to buses in 1946. (Courtesy Craig Rasmussen collection.)

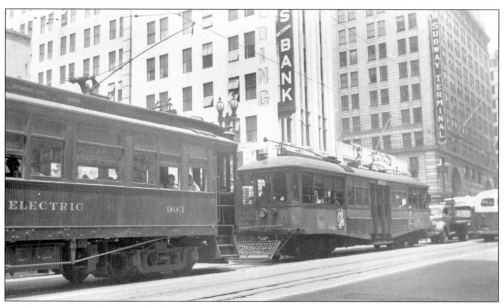

In July 1941, just a few months before the United States's entry into World War II, this view looks north on Hill Street between Fourth and Fifth Streets. A big Pacific Electric car, No. 933, heads for Venice while Los Angeles Railway Type C No. 63 serves on the A Line. The PE car ran on railroad standard-gauge tracks that were 4 feet, 8.5 inches wide, while LARY used rails that were 3 feet, 6 inches wide. Both used one common rail. This a Los Angeles Motor Coach (the joint LARY/PE operation) bus at right, and above the street at right is the Subway Terminal Building. (Courtesy Craig Rasmussen collection.)

Streamlined P car No. 3020 is westbound on First Street in the late 1930s from an eastern view on Spring Street. First Street is being widened so tracks will be shifted to the street's new centerline. (Courtesy Craig Rasmussen collection.)

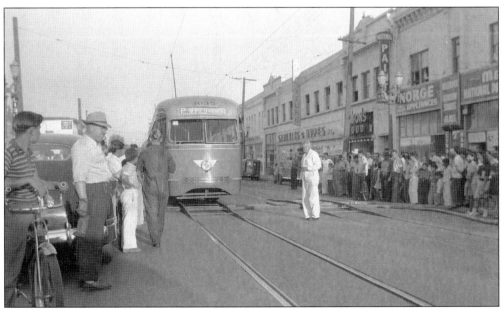

Westbound P car No. 3035 is crossing a special hose jumper that allows a fire hose to go across First Street to help fight a blaze. A lot of bystanders are out to see the excitement here in 1941.

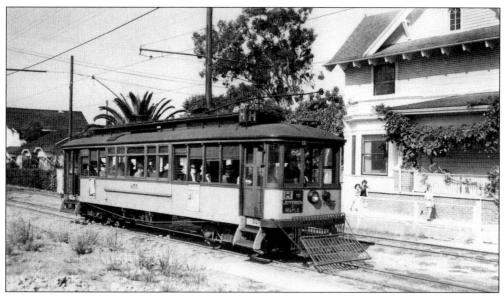

Los Angeles Railway car No. 655 is eastbound on the H Line private right-of-way between one block east of Vermont Avenue and Rampart Boulevard, between Second and Third Streets, in 1942. (Courtesy author collection.)

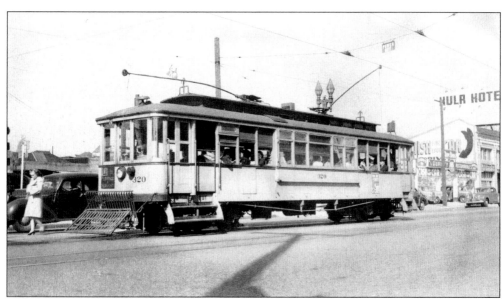

U Line streetcar No. 320 is seen operating on Figueroa Street at Washington Boulevard in 1943. Streetcars that were long ready for retirement extended their careers through the war. Materials that would have been used for replacement buses were instead used by the military for the war effort. (Courtesy author collection.)

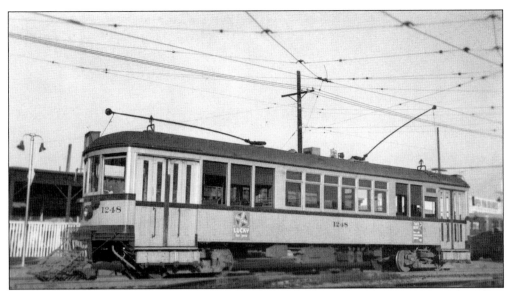

At the Pico and Rimpau Boulevards loop in February 1940, P car No. 1248 has just let off its passengers from Los Angeles Railway's busiest line. Those wishing to go further west would board the blue buses of Santa Monica Municipal. The year 1940 is significant, because the City of Los Angeles had mandated two-man streetcar operation from 1939 to 1941, and at that time, there were no female platform employees. LARY fought the ordinance, and by 1941 had set aside the onerous requirement and reverted, line by line, to one-man streetcar operation. (Courtesy Metro Library.)

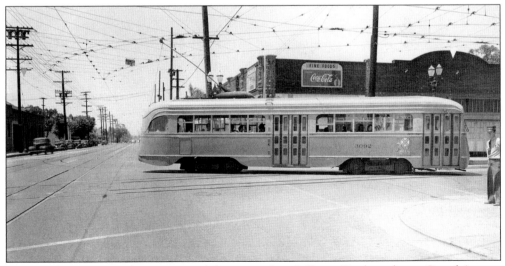

A Streamliner streetcar has just turned the corner from Jefferson Boulevard onto Grand Avenue around 1940. Los Angeles Railway received an additional 35 PCC cars, Nos. 3061–3095, in 1938. They had the same body shell as the first order made in 1937. (Courtesy Metro Library.)

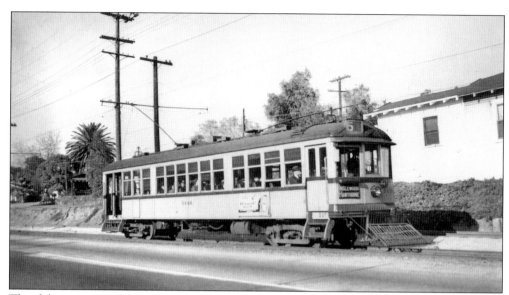

This deluxe streetcar for Los Angeles Railway has upholstered seats and windows in all sections. Type H-3 No. 1446, heading downtown, is seen on the 5 Line's private right-of-way along Cypress Avenue near Division Three in October 1942.

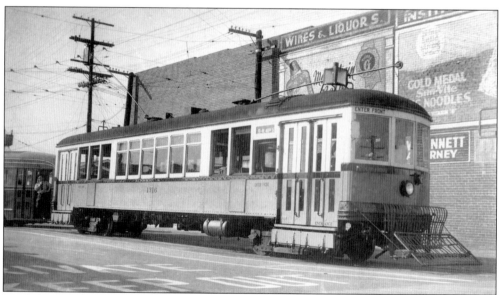

Pinch-hitting for a PCC, H-4 car No. 1316 is seen on a J Line South Gate loop off Seville Avenue in February 1943. (Courtesy author collection.)

Five

LOS ANGELES TRANSIT LINES
1945–1958

World War II was in its final year when the Huntington estate sold its majority interest in LARY to Chicago-based National City Lines (NCL), whose main stockholders were the five Fitzgerald brothers. They had earned an anti-streetcar reputation in other cities, so Angelenos expected that the renamed Los Angeles Transit Lines (LATL) would convert to more buses. But the NCL was blamed for what the LARY might have done anyway as the times moved on—converting streetcars to buses. However, this is not to imply that the Fitzgeralds were good guys.

They began at war's end to bite into the most marginal of the streetcar lines, the shuttles. But bigger things were on their minds, like the massive 1947 conversions of LARY streetcar lines H, U, 3, D, and O beginning on August 3. Line by line, conversions were carried out, and another large changeover occurred on May 22, 1955, as buses did away with lines F, 5, 7, and 8. As well, portions of the 9 and W Lines were combined. The remaining W Line was converted in 1956, leaving only streetcar lines J, P, R, S, and V. Also left were two trolley bus routes.

Pro-bus management also faced the end of gas rationing and the resumption of automobile production as peacetime arrived. The postwar years saw more people moving to new suburbs and using automobiles as their primary means of transportation. Los Angeles Transit Lines could only raise fares to meet rising expenses. These increases chased away even more customers.

Then a federal antitrust action was brought against National City Lines, which was partially owned by bus manufacturers and tire and fuel suppliers. NCL and the other companies were fined $5,000 each. These were barely slaps on the wrist in 1949 terms. They were also forced to sell their NCL stock.

The joint LATL/Pacific Electric operation, the Los Angeles Motor Coach Company, was dissolved in 1949. Its fleet, routes, and other assets were divided by the two owners. The decline in ridership continued into the 1950s, as traffic jams and growth caused citizens to look again to rapid public transit.

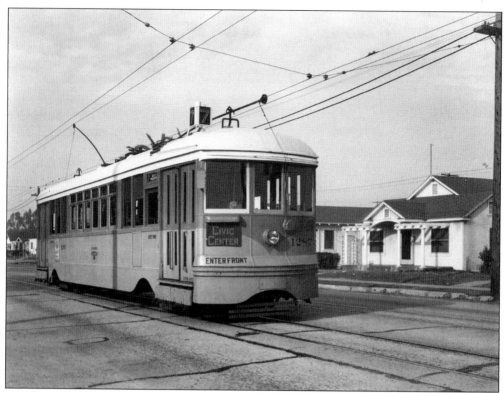

Freshly painted in the Los Angeles Transit Lines' "fruit salad" livery, Car No. 1287 poses for an official-record shot on Second Avenue, near Division Five, c. 1946. It bears the white roof, which was replaced in the 1950s with a more functional tan roof. All streetcars, except PCCs, received tan roofs, while trolley and motor buses retained white. (Courtesy Metro Library.)

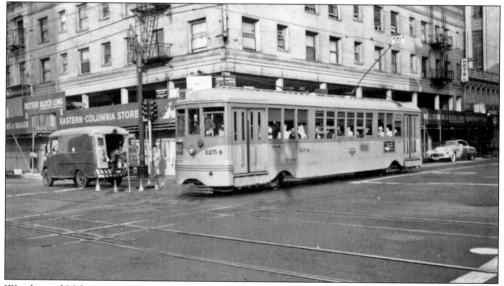

Westbound N Line car No. 1254 crosses Hill Street in September 1950 just before the line was converted to buses. Note the stubs of the narrow-gauge rails of LATL streetcar lines on Hill Street, which had previously been converted to bus lines. (Courtesy author collection.)

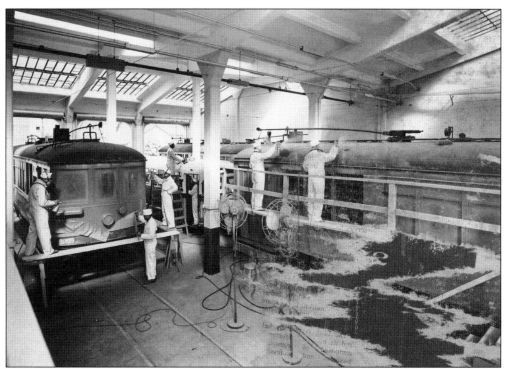

Inside South Park Shops, Los Angeles Transit Lines painters are busy applying new colors in bold yellow, green, and white. The paint scheme was nicknamed "fruit salad" in 1946. (Courtesy Metro Library.)

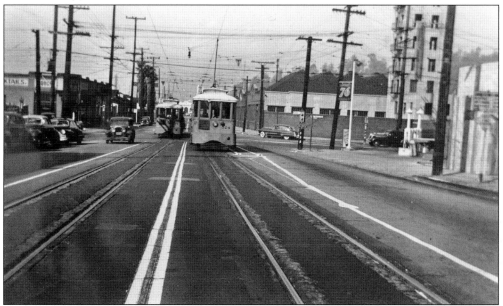

Two Los Angeles Transit Lines Type B cars, now in LATL livery, are seen here on Pasadena Avenue at San Fernando Road on the 9 Line in May 1948 with Acme semaphore signals to control the intersection. At right is a rectangular Union Oil "76" gas station sign. (Courtesy Craig Rasmussen collection.)

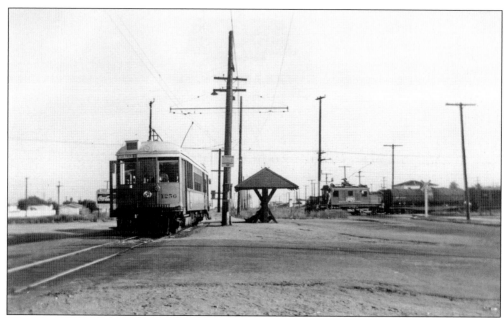

The 7 Line car No. 1256 is at the 116th Street Terminal in July 1946. Before the 1911 merger, this terminal used to be part of the Los Angeles and Redondo Railway's Moneta Division, serving Gardena and terminating in Redondo Beach. In the distance, electric locomotive No. 1620 of the Pacific Electric is pulling freight from El Segundo, home of Standard Oil's second refinery. (Courtesy Craig Rasmussen collection.)

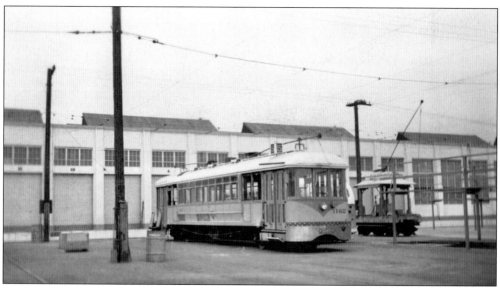

Los Angeles Transit Lines Type F No. 1162 gets the "modernizing" treatment at South Park Shops in 1947. In the process, it lost its external Eclipse fenders in favor of Lifeguards under the end, as well as new doors and folding steps. The skirting applied over the ends gave this car, and many others, a boxy look. (Courtesy author collection.)

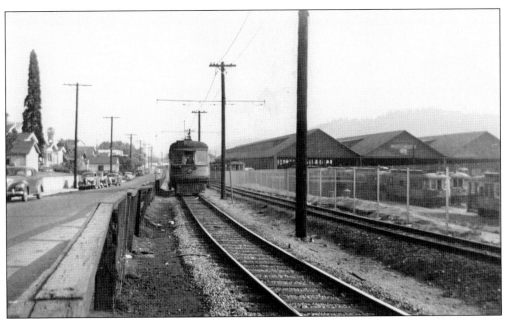

Still in its LARY livery, H-3 Type No. 1431 goes on a side-of-the-road right-of-way along Cypress Avenue, passing Division Three in June 1946. (Courtesy Craig Rasmussen collection.)

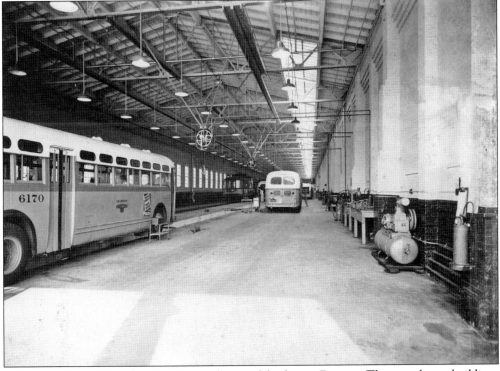

The new management of LATL soon made one of the former Division Three car house buildings into a bus-maintenance facility. This view dates from 1945. This remained as the last streetcar-era structure until the 1970 Northridge earthquake, after which the unreinforced brick building was condemned and soon razed. (Courtesy Metro Library.)

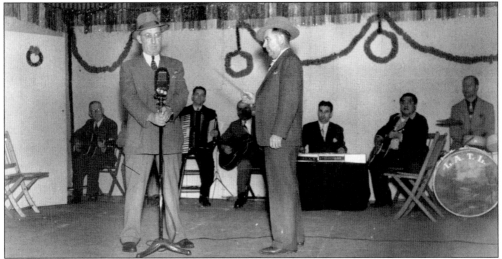

W. Ralph Fitzgerald, one of the five Fitzgerald brothers who controlled Los Angeles Transit Lines and LATL president, frowns as he adjusts a microphone *c.* 1946. Benson M. "Barney" Larrick, LATL's operating manager, known to many as the "hatchet man," is at his left. This looks like a festive Christmas party, but is it? (Courtesy Metro Library.)

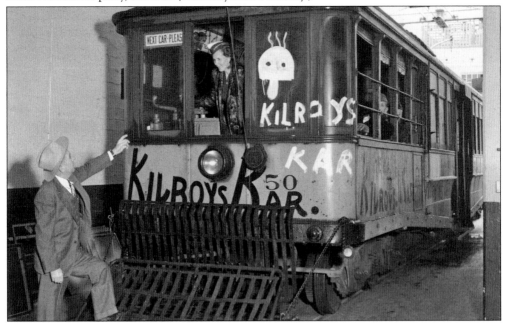

Los Angeles Transit Lines operating manager Barney Larrick gives streetcar No. 50 to Mrs. Harold Coffman, winner of a zany 1947 contest asking entrants for their version of the origin of a mythical character named Kilroy, who was supposedly created by a northeastern shipyard welder. He began writing the phrase, "Kilroy was here," on everything he checked to stop double counting and double payment to riveters for work he had already done. The phrase, and the long-nosed character seen here, began popping up all over World War II Europe, especially where U.S. servicemen had been, and Kilroy became very popular. Larrick resigned as LATL operating manager and from the board of directors the following January. Sowbelly No. 50 ended up in the scrap yard. (Courtesy Metro Library.)

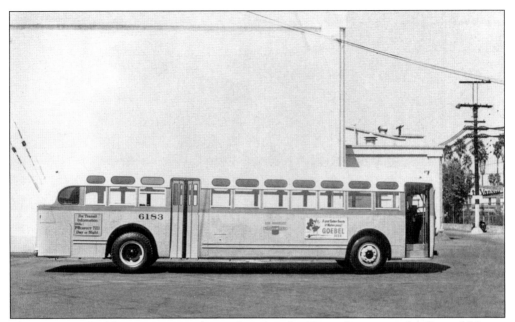

The epitome of public transit, according to Los Angeles Transit Lines, was the General Motors diesel bus, like the No. 6183 shown here at Division Five on Fifty-fourth Street and Second Avenue c. 1947. No fixed plant was needed for these vehicles, nor were tracks or wires required, and they were less investment for the stockholders. (Courtesy Metro Library.)

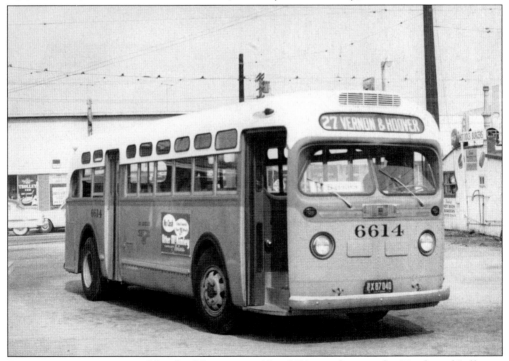

Buses came in many sizes, like the 36-passenger No. 6614 seen here at the Tenth and Jefferson Loop of the streetcar J Line in 1955. They were often used for shuttle or feeder lines serving outlying neighborhoods. (Photograph by Jim Walker.)

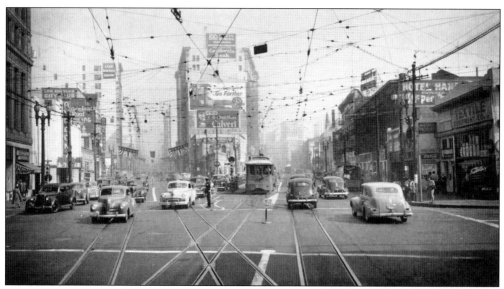

A downtown scene in the late 1940s looks north at Ninth Street where Spring Street (left) diverges from Main Street (right). Streetcar lines came together and the standard-gauge Pacific Electric line to Watts turned left onto Ninth Street. (Courtesy Joe Moir collection.)

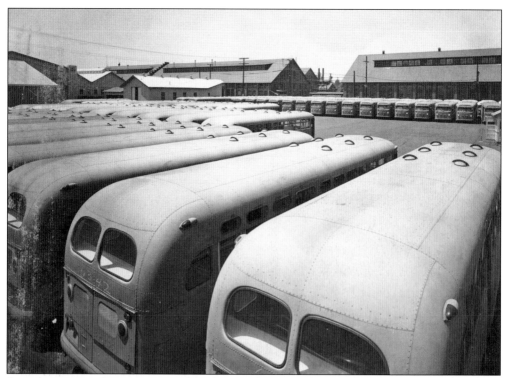

Some buses arrived in primer paint like these at the east end of South Park Shops in 1946. LATL was so anxious to put buses on the street that many of them began their service in gray primer. (Courtesy Metro Library.)

Many streetcars, including the Huntington Standard No. 286 seen here southbound on Central Avenue at Adams Boulevard in June 1947, were not given the chance to be painted in LATL colors as they went to the scrap yard in LARY livery. The U Line was converted to buses in August of that year. (Courtesy Craig Rasmussen collection.)

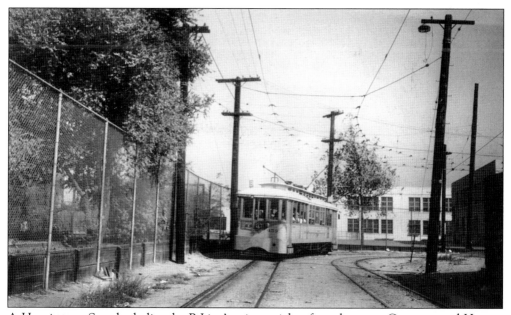

A Huntington Standard plies the B Line's private right-of-way between Compton and Hooper Avenues behind Thomas Jefferson High School around 1946. It is bound for its terminal at Miller Avenue and City Terrace on the east side. (Courtesy Metro Library.)

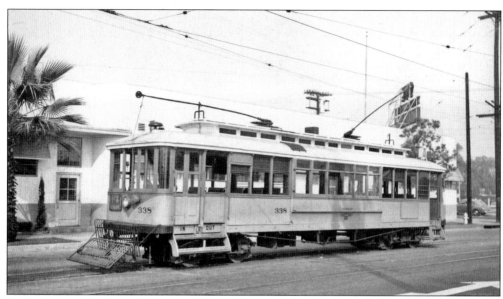

Decked out in the fruit salad paint scheme of Los Angeles Transit Lines, Car No. 338 sits at the V Line Terminal at Leonis Boulevard and Downey Avenue in the city of Vernon around 1946. (Courtesy author collection.)

Included in a lineup of rubber-tired support, seen at Division Two's Sixteenth Street Garage c. 1945, are two Mack truck "Bertha" wreckers. (Courtesy Metro Library.)

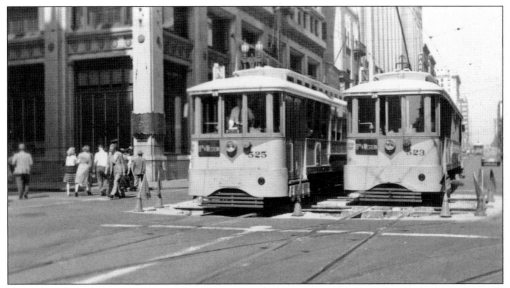

Two N cars pass at Fourth and Spring Streets in downtown Los Angeles in the late 1940s. Both cars, Nos. 525 and 523, have lost their Eclipse fenders and were replaced by Lifeguard fenders with skirting around the bottom ends. (Courtesy author collection.)

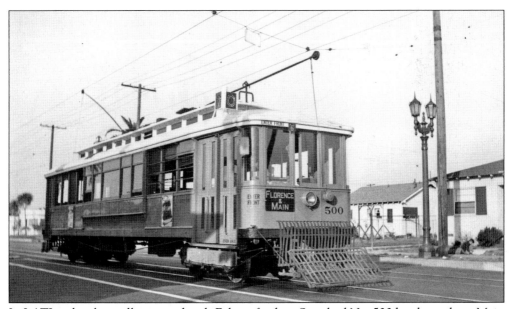

In LATL colors but still equipped with Eclipse fenders, Standard No. 500 heads south on Main Street to the Florence Avenue Terminal of the O Line, one of the casualties of the 1947 conversions. (Courtesy author collection.)

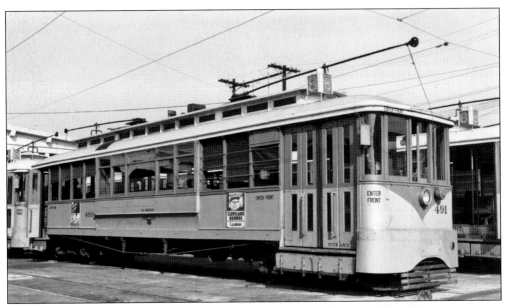

BF Standard 491 sits at Division Five between 8 Line runs in the late 1940s. BF was a variation with single-rear doors. This type could only be used on lines operated by one person. The car was sent to scrap in 1952. (Courtesy Craig Rasmussen collection.)

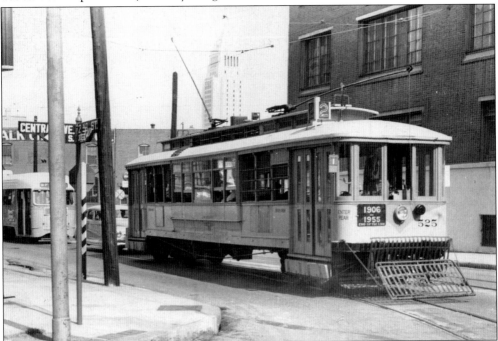

The finale for the Huntington Standards was this excursion in 1955. Car No. 525 had been in dead storage since 1950 at Division Three. One end of the car was reequipped with an Eclipse fender for the day that was "borrowed" from a maintenance car. It is seen here on Second Street at Central Avenue. Note the 1950 variation on LATL colors with the tan roof (LATL called it "taffy tan") and green replacing white on the upper edges of sides and ends. (Photograph by Jim Walker.)

A Streamliner PCC heads east on Seventh Street at Broadway toward the R Line loop at Whittier Boulevard and Brannick Avenue in 1956. (Photograph by Jim Walker.)

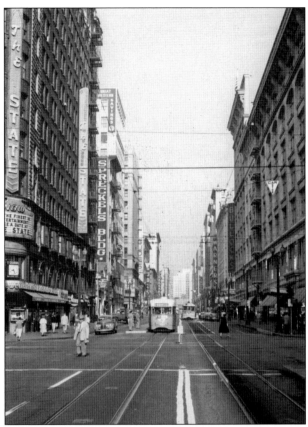

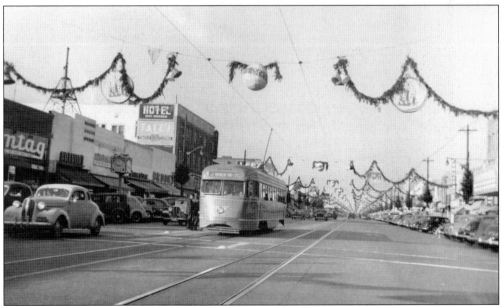

Downtown Huntington Park has its 1945 Christmas decorations up as the J Line PCC No. 3088, still in yellow LARY livery, heads south on Pacific Boulevard to its terminal loop at Seville Avenue and Palm Place in South Gate. (Courtesy Craig Rasmussen collection.)

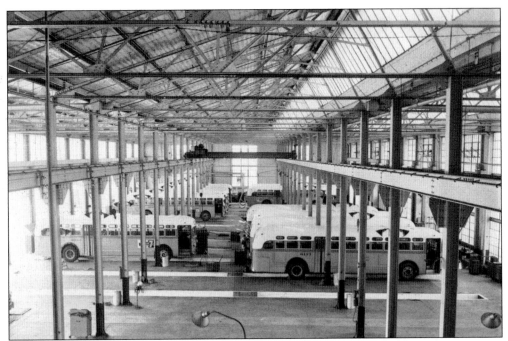

One of the features of the Sixteenth Street Garage of Division Two was this large bus shop, built in 1926. It used to see double-deckers and other early models. But by the late 1940s, most of the buses serviced there by Los Angeles Transit Lines were General Motors diesels. (Courtesy Metro Library.)

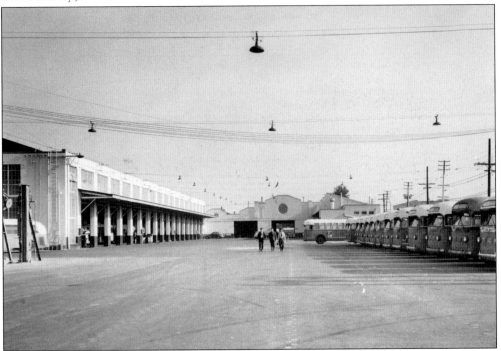

This 1945 view looks northeast to the Division Two yard. The Sixteenth Street Garage is at left. (Courtesy Metro Library.)

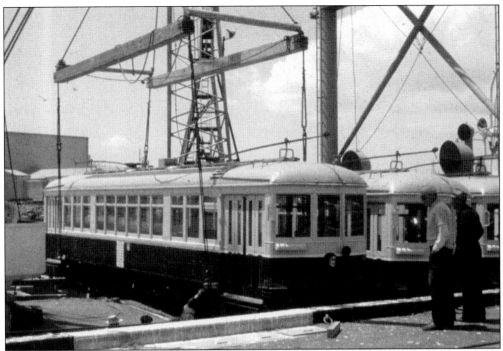

In 1956, forty-one of the Type H-4s were sent to Korea through a government foreign-aid program to rehabilitate street lines in Seoul and Pusan, both of which happened to be the same 3-foot, 6-inch gauge track used in Los Angeles. This view shows one of the cars being lowered onto a ship's deck. (Photograph by Jim Walker.)

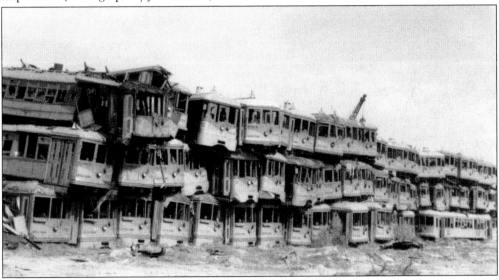

The last resting place for many Los Angeles streetcars was the giant National Metals and Steel scrap yard on Terminal Island. The truck assemblies, which included the motors, were immediately removed upon arrival before the bodies—some that were wood or a combination of steel and wood—would be stacked up like in this 1957 view. Then on very foggy nights, someone would set "accidental" fires to burn all the wood, thus circumventing pollution laws. (Photograph by Jim Walker.)

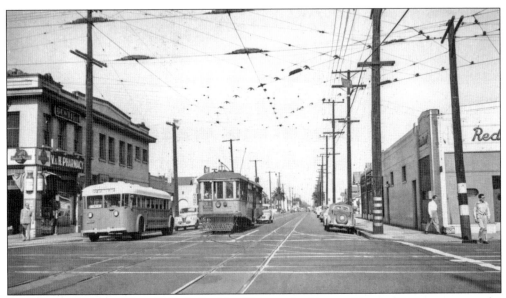

An eastbound V Line Type C Sowbelly, No. 57, is on the Vernon Line in 1947 en route to the city of the same name. Alongside it is a Twin Coach–built bus, in the 1700 Series, on the 27 Line. (Courtesy author collection.)

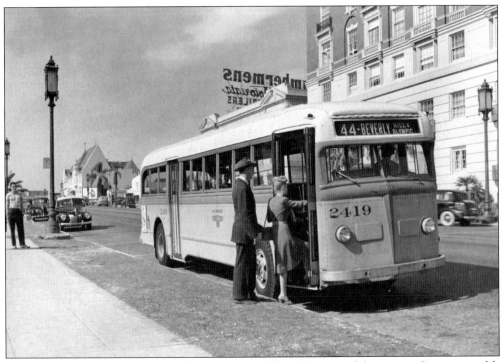

Eastbound Los Angeles Transit Lines bus No. 2419, a White Motors model, pauses at Commonwealth Avenue on Wilshire Boulevard in the 1940s for a publicity photograph. Note the distinctive "lantern" streetlights. (Courtesy Metro Library.)

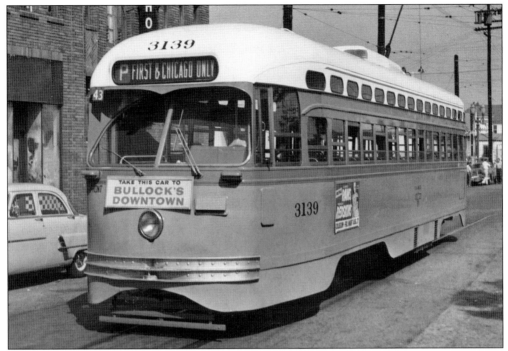

All-electric PCC No. 3139 is at the First and Chicago Streets short-turn loop on the P Line in East Los Angeles in 1956. This series of 40 cars, known as Type P-3, arrived in 1948. For an anti-streetcar operation to buy new streetcars in the late 1940s was a shock, and it has long been debated if the purchase was influenced by an antimonopoly probe of the Fitzgerald Brothers' National City Lines by the federal government. National City Lines was the parent company of LATL. (Courtesy Metro Library.)

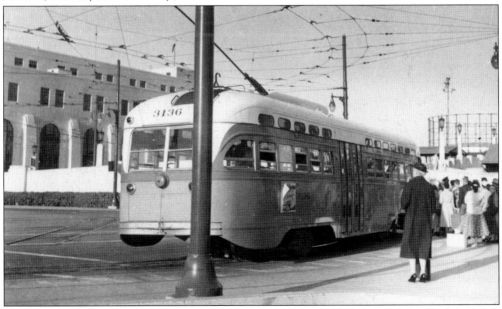

New P-3 Streamliner No. 3136 is on the Union Station loop in 1948, probably for display. At left is the Terminal Annex Post Office. (Courtesy Metro Library.)

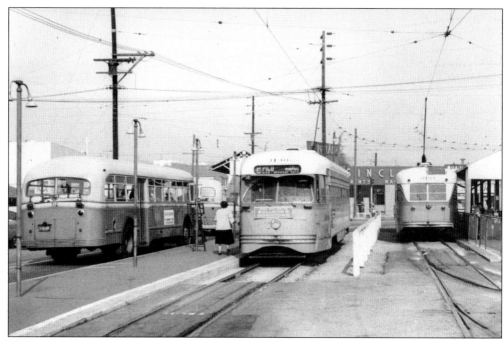

The P Line's western terminal was this loop at Pico and Rimpau Boulevards. Those going further west could board a Santa Monica Municipal bus (at left) like this one built by White Motors. There was a corresponding bus-to-streetcar lane out of the picture at right. It is 1956. (Photograph by Jim Walker.)

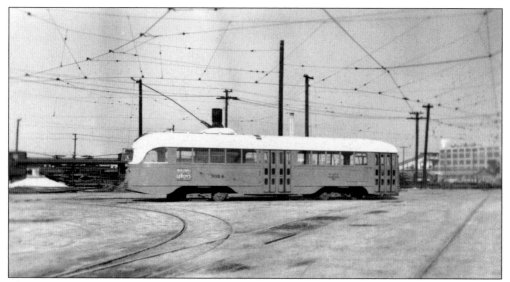

This J Line "tripper"—a rush-hour car that didn't go to end of line—is shown at the Vernon Yard before the loop was built when the V Line converted to PCCs. (Courtesy author collection.)

H-4 No. 1201 is southbound on the W Line at Figueroa and Twenty-eighth Streets in March 1951. (Courtesy Craig Rasmussen collection.)

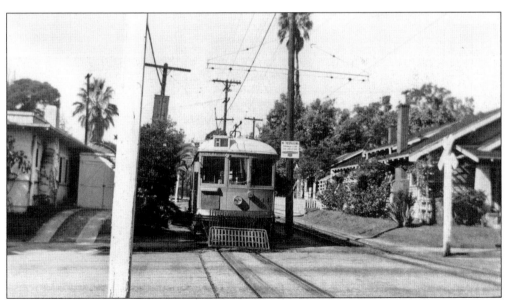

Eastbound H car No. 1244 is about to cross Dillon Street on its private right-of-way between Vermont Avenue and Rampart Boulevard en route to its eastern terminal at Fifty-third and Wall Streets in 1946. Note that LATL had not yet gotten the fender ordinance changed. (Courtesy Craig Rasmussen collection.)

A westbound Los Angeles Transit Lines bus pulls back into traffic lanes from a special bus zone along Vermont Avenue on the Hollywood Freeway. This publicity photograph of No. 6927 is from the late 1940s. Where are all the automobiles and trucks? (Courtesy Metro Library.)

Posing at South Park Shops is LATL "candy cane" streetcar 1254 that was specially painted for Christmas in 1948. A PCC and a bus were also painted in the festive design. (Courtesy Metro Library.)

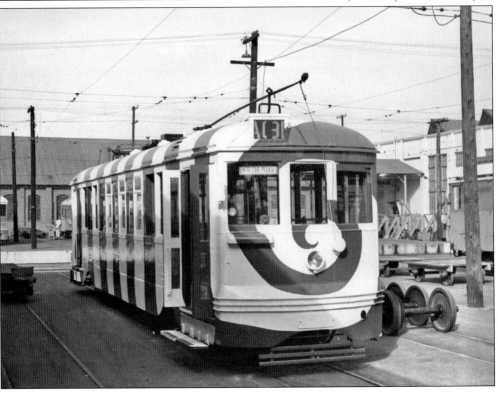

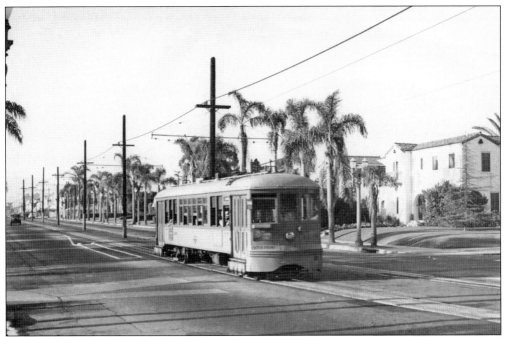

This image looks north on Larchmont Boulevard at Second Street between 1947 and 1950, when part of the S Line service traversed this thoroughfare from the wye at Melrose Avenue to Third Street en route to its Manchester and Central Avenues Terminal. Shown is Type H-4 No. 1335. (Courtesy Metro Library.)

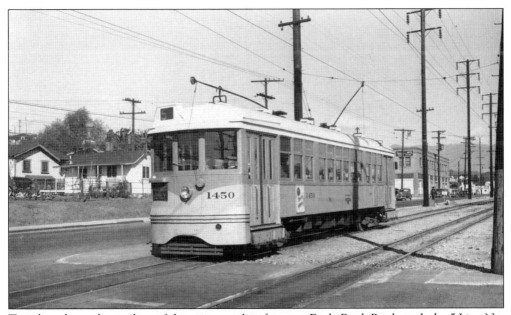

Traveling down the median of the private right-of-way on Eagle Rock Boulevard, the 5 Line No. 1450—the highest numbered of the Type H cars—is just about to cross Avenue 37 on its trek to Hawthorne in 1948. (Courtesy Craig Rasmussen collection.)

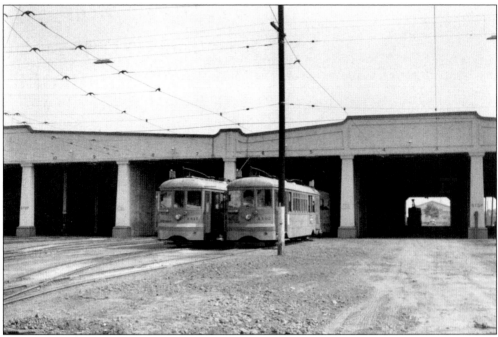

At Division Five, time was running out in the 1950s for all the streetcars kept there, since soon it would be an all-bus facility. Some tracks have already been moved. (Photograph by Jim Walker.)

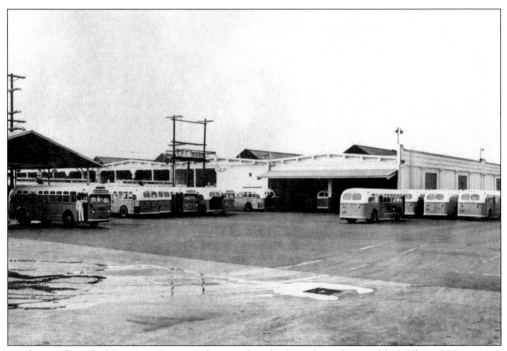

At the south end of Division Five's car houses, bus facilities have been added. This 1940s view is from the southeast corner of the property. (Courtesy Metro Library.)

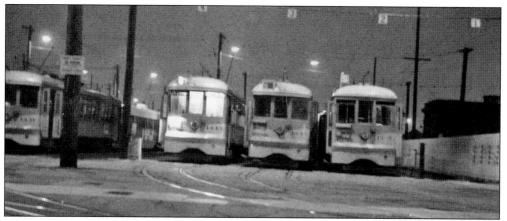

This is a 1958 night view of the outside yard of Division Four. Type H cars were still used on the R Owl, a post-midnight run on the R Line, as it reversed ends near Seventh Street and Central Avenue. (Photograph by Jim Walker.)

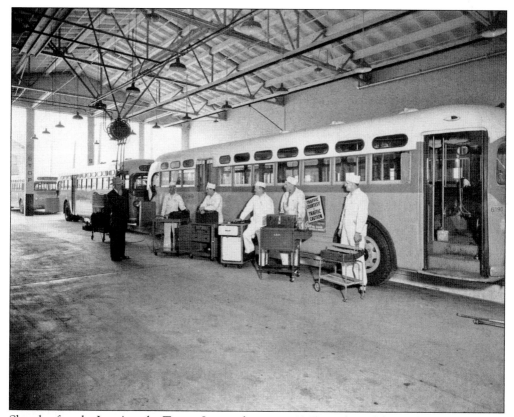

Shortly after the Los Angeles Transit Lines takeover in 1945, one bay of the car house at Division Three was converted to bus maintenance. This view, at the southern end of the building, shows mechanics in new white overalls in front of Bus No. 6190. (Courtesy Metro Library.)

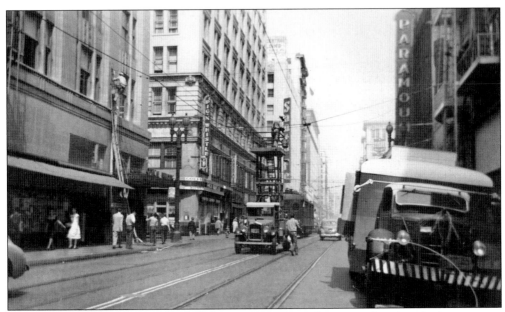

It wasn't long after this shot was taken that Sixth Street in downtown Los Angeles became one way (east) as crews installed a trolley coach wire between Broadway and Hill Street in 1946. Behind the LATL tower truck is an eastbound Pacific Electric trolley rail-post office car waiting for the truck to get out of its way. (Courtesy Craig Rasmussen collection.)

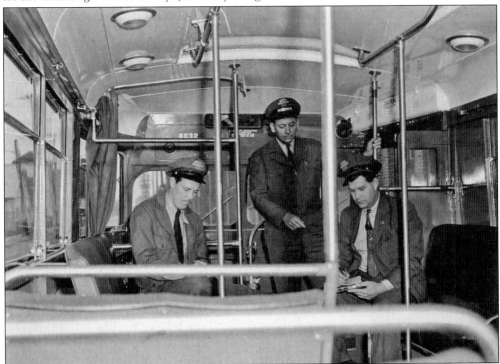

An instructor is training drivers aboard trolley bus No. 8032 on a training loop built near the South Park Shops. The 3 Line, which was equipped with PCC streamlined streetcars, would become the 3 Trolley Bus Line on August 3, 1947. (Courtesy Metro Library.)

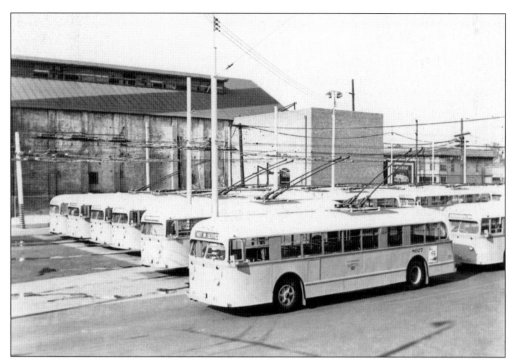

Trolley buses pretty much took over Division One from streetcars by 1948, and the division's last two streetcar lines, N and V, were moved to other divisions on January 1, 1950. The one remaining car house, on the east side of Central Avenue at the north side of Commercial Street, continued to be used for dead storage until the end of streetcars in 1963. Seen at the division are some of the first order of trolley buses, the 8000s. (Courtesy Metro Library.)

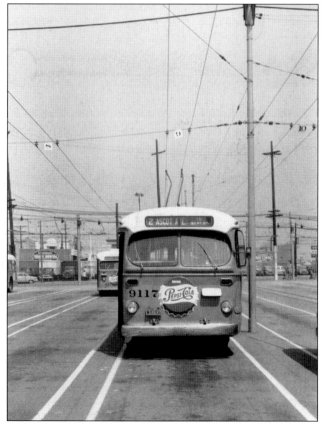

The last order of trolley buses by Los Angeles Transit Lines were for the 9100s, which were delivered in 1948 at a quantity of 30. No. 9117 is seen at Division One in 1956, its poles damaged by some well-meaning person who tried to back up without assistance. (Photograph by Jim Walker.)

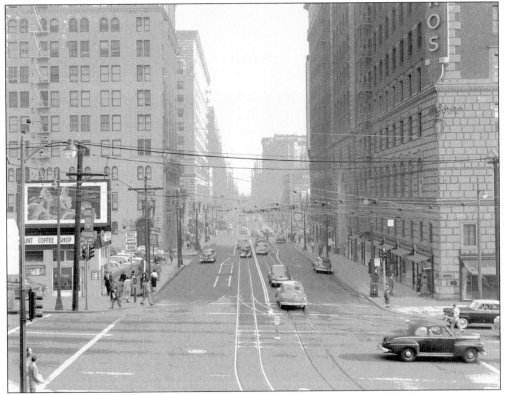

This eastward view of Seventh Street from Figueroa Street in the 1950s is likely one of the few in which a streetcar is not in sight. (Courtesy Metro Library.)

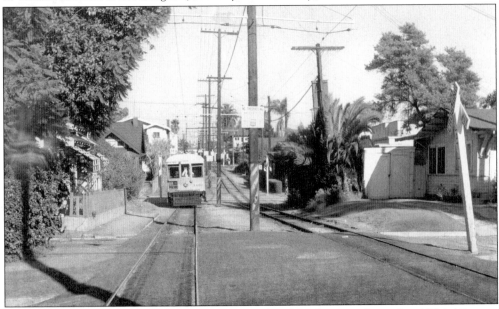

Passing through a residential district on a private right-of-way between Second and Third Streets, and running between a block east of Vermont Avenue and Rampart Boulevard, is H Line car No. 1440 headed for its terminal on Melrose and Western Avenues. (Courtesy Joe Moir collection.)

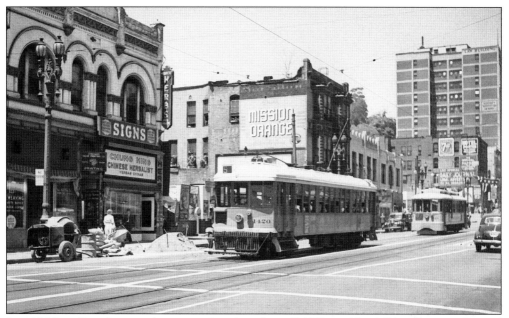

It is 1946 on Broadway in downtown Los Angeles as LATL car No. 1420 pulls up to Second Street en route to the 5 Line Terminal at Hawthorne. Although the fender ordinance has been changed to allow under-car Lifeguard fenders, as on the car behind, shop forces have not yet made the changes necessary to replace No. 1420's external Eclipse fenders. (Courtesy Craig Rasmussen collection.)

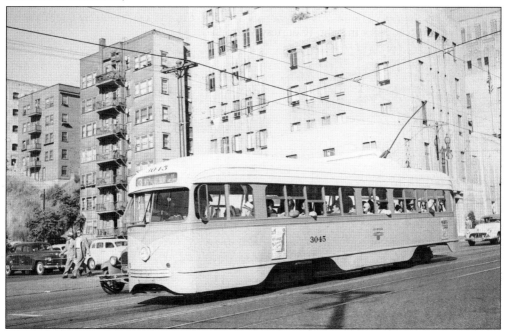

Streamliner PCC No. 3045 is westbound on Fifth Street in downtown Los Angeles, c. 1946, on the 3 Line just west of Grand Avenue. The line, despite having newer cars, was converted to trolley buses the next year as the city changed Fifth Street to one-way westbound traffic and Sixth Street to one-way eastbound. (Courtesy Craig Rasmussen collection.)

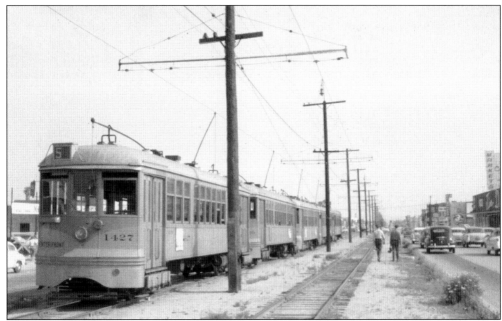

Streetcars are lined up on the northbound 5 Line track on the Center Street right-of-way on Hawthorne Boulevard at Arbor Vitae Avenue in Inglewood in 1955. It is waiting for the end of the horse-racing day at nearby Hollywood Park. During this time, regular 5 Line streetcars would use the southbound track for both directions. This would be the last year that streetcars would serve this venerable horse-racing track. (Photograph by Jim Walker.)

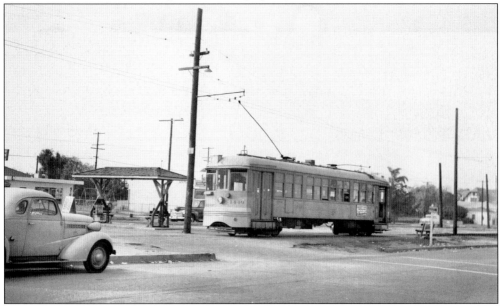

F Line streetcar No. 1449 awaits northbound passengers at its 116th Street Terminal in a private right-of-way in the center of Vermont Avenue. The year is 1955, and shortly thereafter, the line will be converted to buses. This car models the final version of Los Angeles Transit Lines' livery: yellow below the windows, green from belt rail to the top of the side, and a "taffy tan" roof color. (Photograph by Jim Walker.)

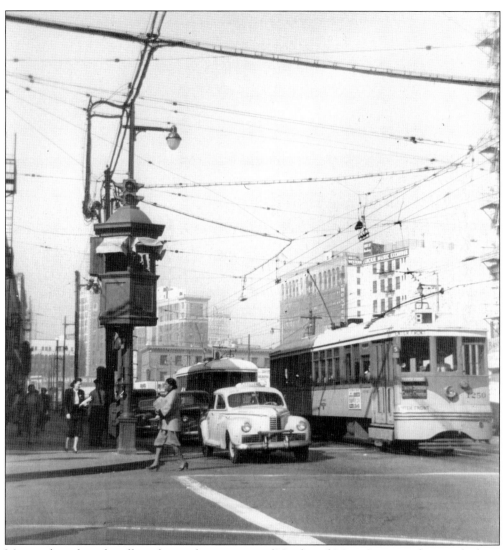

Mounted on the sidewalk at the southeast corner of Ninth and Main Streets is this interlocking tower. It controlled both Yellow Car movements and the Pacific Electric Red Cars of the Watts Local Line, which came west on Ninth Street before turning north (right) onto Main Street. This photograph was taken around 1950. (Courtesy Craig Rasmussen collection.)

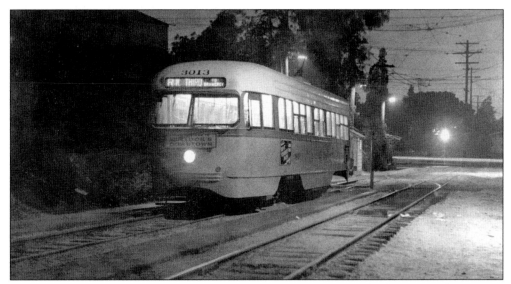

A misty Los Angeles night engulfs R Line No. 3013, waiting at the Third Street and Gramercy Avenue Terminal for its return trip through downtown and its eastern terminal loop on Whittier Boulevard. This had been the private right-of-way for the streetcar 3 Line from Sixth to Third Streets until 1947. A short stub at Third Street was retained as a streetcar terminal, and it lasted until the end of streetcars in 1963. (Courtesy Craig Rasmussen collection.)

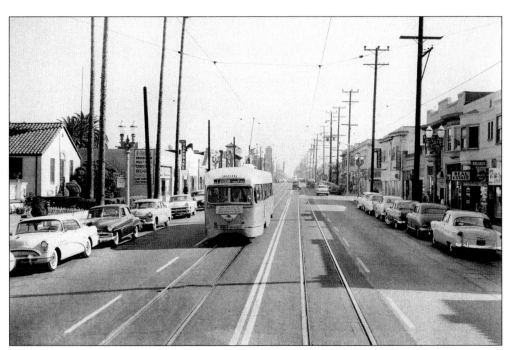

Westbound on Jefferson Boulevard around 1955, Streamliner No. 3006 heads for the J Line loop at Tenth Avenue. Here it passes Prescott Street. (Courtesy Craig Rasmussen collection.)

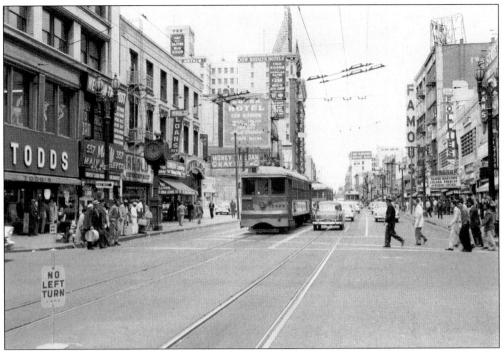

Car No. 1424 is southbound on Main Street at the intersection of Sixth Street on an overcast day in 1955. Note the twin-wire trolley bus overhead for southbound 2 Line trolley buses to turn onto one-way Sixth Street to reach their Division One home base. (Photograph by Jim Walker.)

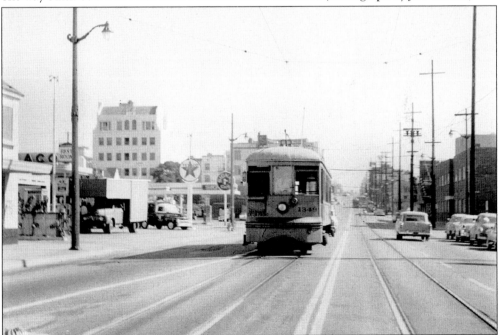

Line S car No. 1349 travels west on Eighth Street in 1956, heading for its Western Avenue Terminal. The S Line was the last streetcar service to use non-PCC cars, and it ran from late 1958 until the end of streetcars in 1963. (Photograph by Jim Walker.)

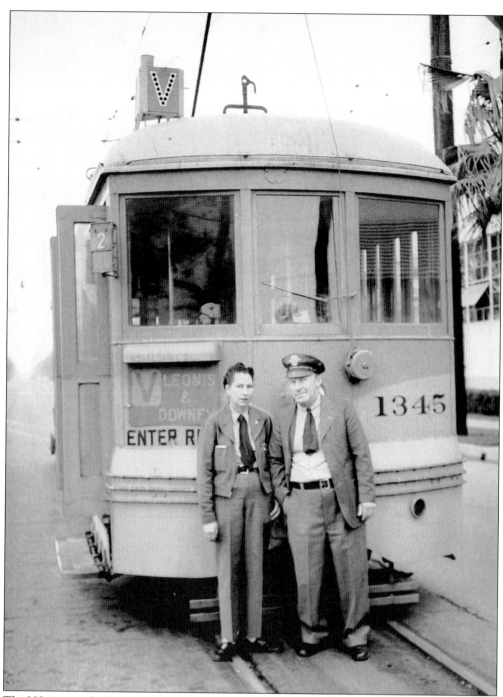

The V Line was the last streetcar route to use two-person crews. In 1954, it was reequipped with PCC cars and cut back to a new loop at Vernon Yard. Its Leonis Boulevard tracks from Pacific Boulevard to Downey Road were abandoned. The conductor and motorman pose in front of Car No. 1345 on Monroe Street, just west of Vermont Avenue, by Los Angeles City College (the former UCLA campus before it moved to Westwood in 1929). With the introduction of PCC cars came the end of two-person crews. (Photograph by Jim Walker.)

Eastbound in 1957 on Seventh Street in downtown Los Angeles, S Line car No. 1434 has just crossed Spring Street en route to its terminus at Manchester and Central Avenues. (Photograph by Jim Walker.)

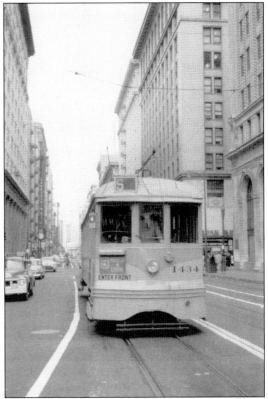

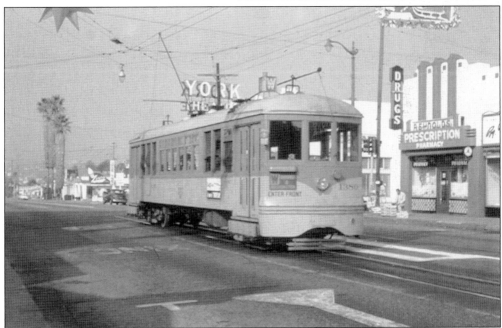

Seen at the York Boulevard and Avenue 50 terminus of the W Line in 1954, Car No. 1380 will soon be on its way through downtown Los Angeles to its other terminus at Washington and Rimpau Boulevards. It was converted to bus operation in 1956.

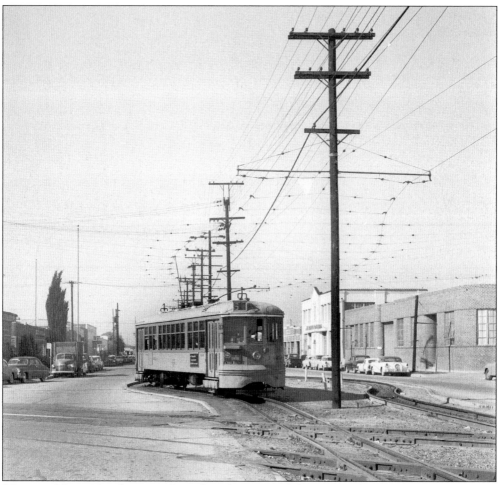

S Line car No. 1428 is shown eastbound on the center-of-the-street right-of-way on Gage Avenue between Avalon Boulevard and Central Avenue. It is stopped for a crossing of the Pacific Electric Wingfoot branch, which served the Goodyear Tire and Rubber Company plant on Central Avenue. The peculiar bulge in the track was installed to swing the cars around a pump house, which was gone by the time this photograph was taken. There was a similar "loop" on the east end of the right-of-way. Both bulges were removed in 1961. (Photograph by Jim Walker.)

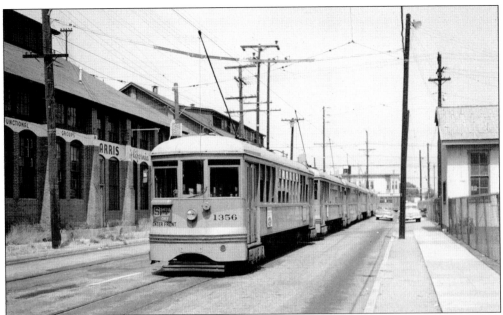

Awaiting the end of a baseball game at nearby Wrigley Field, S Line extras are on Fifty-fourth Street between the old and the new sides of the South Park Shops in 1956. The home team was the Los Angeles Angels of the Pacific Coast League. Purchased in 1921 by chewing-gum magnate Philip K. Wrigley Jr., it was sold by Wrigley's son Philip in 1957 to Walter O'Malley, owner of the Brooklyn Dodgers. O'Malley moved the Dodgers to Los Angeles and played the first season in the Los Angeles Coliseum while building the present Dodger Stadium, into which the team moved in 1962. Despite O'Malley's promise to keep the Angels going, they only played one season in Los Angeles and then became the Spokane Indians in Washington. (Photograph by Jim Walker.)

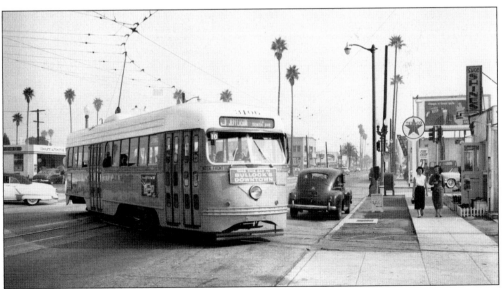

Turning onto the Tenth Avenue loop from Jefferson Boulevard in 1957 is the Los Angeles Transit J Line Streamliner No. 3106. This was part of the batch delivered in 1943 and 1944. (Photograph by Jim Walker.)

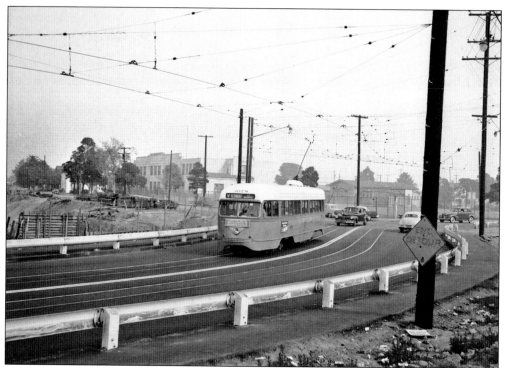

During construction of the north/south Harbor Freeway in the mid-1950s, Vernon Avenue was kept open by use of a temporary "shoo-fly" while the future was being built. Here V Line car No. 3078 heads westbound on Vernon Avenue around 1956. (Photograph by Jim Walker.)

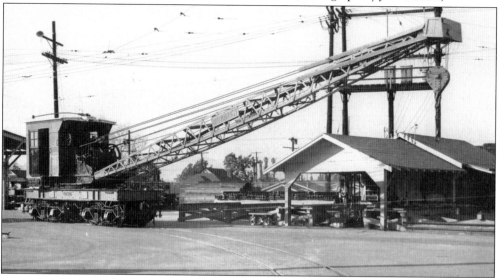

For the big jobs, derrick No. 9226, the "Big Hook," was just the ticket. This 15-ton derrick was purchased from the Brown Hoist Company in 1914 and was self-propelled. It is seen in the Los Angeles Transit Lines Pepper Avenue Yard at the north end of Division Three in the late 1940s. Unfortunately, when the 1955 conversions of streetcar lines to bus operation were carried out, Division Three lost its rail connection to the rest of the system. It was decided that No. 9226's continued presence was not needed, so it was sold for scrap in 1956. (Courtesy Metro Library.)

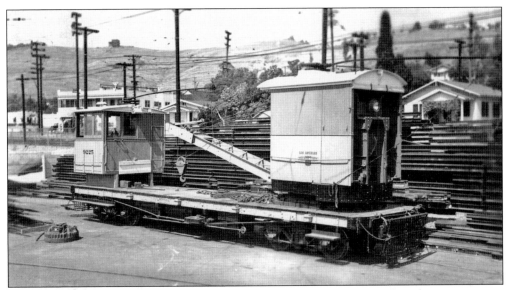

Crane car No. 9225 was built in South Park Shops in 1912 using a Whiting five-ton capacity derrick mounted on a swivel base. It is seen here at the Pepper Avenue Yard in 1954. The derrick lasted until 1962, when it was trucked to the Orange Empire Railway Museum at Perris, California, for preservation, along with line car No. 9350 and rail grinder No. 9310. (Photograph by Jim Walker.)

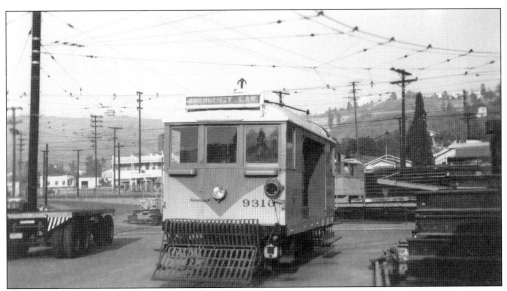

This little car was rail grinder No. 9310. It was one of two such cars on the Yellow Car system. The other was Car No. 9311, which was scrapped in 1939. No. 9310 was seen out usually late at night using abrasive wheels running back and forth to tediously grind out corrugations made by service cars, often at places where they would apply brakes coming into a passenger stop. This car also went to the Orange Empire Railway Museum in 1962. It was photographed at the Pepper Avenue Yard in 1954. (Courtesy author collection.)

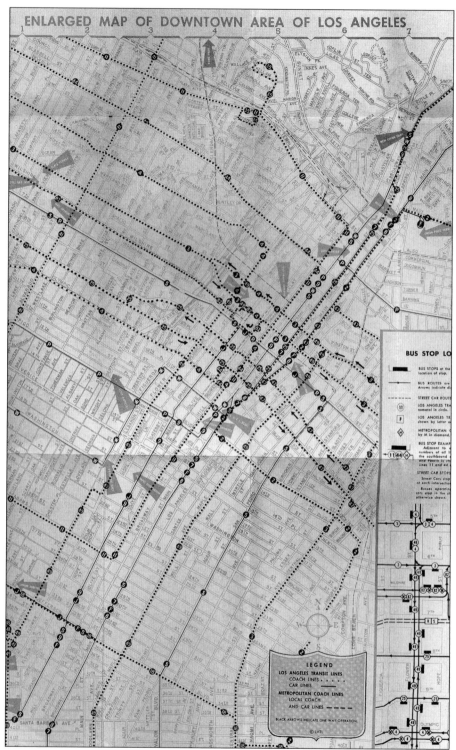

This is the official map of the Los Angeles Railway Yellow Cars system as it appeared in 1954. (Courtesy Metro Library.)

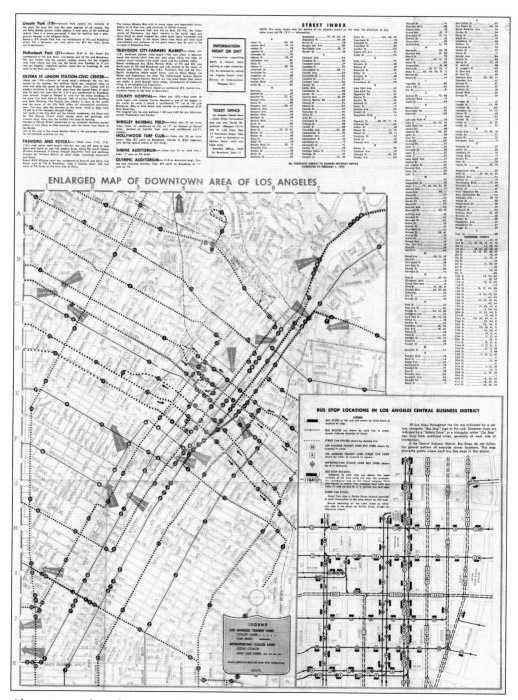

Above is an enlarged inset map that appeared on the back of the official 1954 Yellow Cars map. (Courtesy Metro Library.)

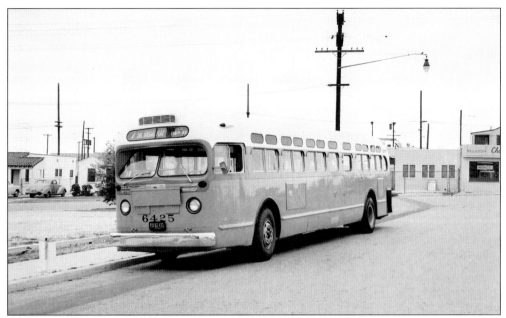

The streetcar 7 Line on Broadway had just been converted to bus operation when this May 1955 view was taken of General Motors diesel bus No. 6425 on Broadway, near Eleventh Street, ready for its next foray north into downtown Los Angeles. (Photograph by Jim Walker.)

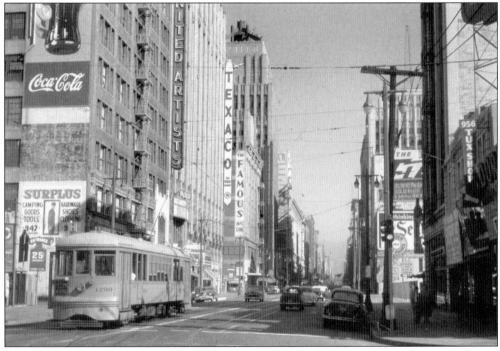

Los Angeles Transit Lines streetcar No. 1290 pauses southbound on Broadway at Olympic Boulevard in 1956 during an excursion by enthusiasts. It was a lazy weekend morning, and things were a bit quieter than 50 years later. (Photograph by Jim Walker.)

Six

THE LAST
YELLOW CAR YEARS
1958–1963

On March 3, 1958, Los Angeles Transit Lines, along with Pacific Electric's passenger-system successor, Metropolitan Coach Lines, were sold to a public agency, the Los Angeles Metropolitan Transit Authority (LAMTA). LAMTA was formed in 1951 with the limited goal of building a monorail line from the San Fernando Valley to Long Beach via the bed of the Los Angeles River.

The new operation hired much of the same anti-rail management as its two major predecessors, so it was not surprising that efforts continued to convert the balance of the Yellow Car streetcar lines (five) and the two trolley bus lines, as well as the last four Red Car rail routes, to bus operations. Although efforts were expended by LAMTA to build rail rapid transit, the public agency failed to generate the public's support. The critical step of asking the public to pay for it was always the stumbling block that could not be surmounted. So the area residents stuck to the status quo with a freeway system that was increasingly jammed despite the construction of yet more freeways. LAMTA's efforts to provide express bus service—the Freeway Flyer for instance—met with a lukewarm reception. It was felt that only those who didn't own an automobile would ride public transit.

Meanwhile, plans were being made to convert the last five streetcar routes (lines J, P, R, S, and V) and the two trolley bus routes (lines 2 and 3) to diesel bus operations. The conversion was carried out on March 31, 1963.

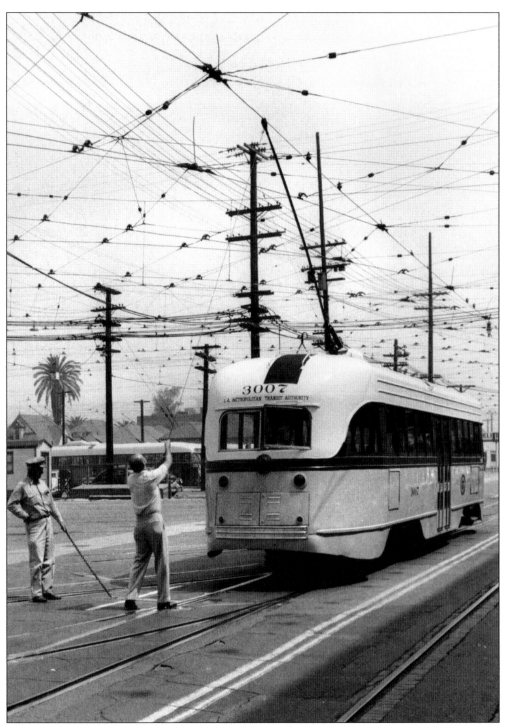

A switching crew puts Streamliner No. 3007 into the south outdoor yard on Division 20 near Georgia Street and Pico Boulevard in downtown Los Angeles in 1962. The former name of this facility was Division Four. After the abandonment of streetcars in 1963, this property was leveled and is now part of the Los Angeles Convention Center. (Courtesy Metro Library.)

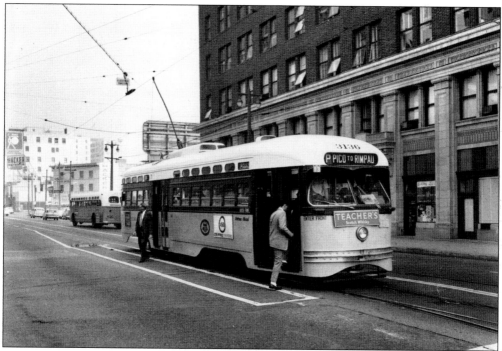

P Line car No. 3136 of the Los Angeles Metropolitan Transit Authority is servicing riders at the southbound safety zone on Broadway at Eleventh Street. The building at right is LAMTA headquarters, built by Henry E. Huntington in 1920–1921. It was first occupied in 1921 by Los Angeles Railway personnel before being used by the Los Angeles Transit Lines and the Los Angeles Metropolitan Transit Authority for headquarters. It was then used by the Southern California Rapid Transit District for its center of operations until 1976. (Courtesy Metro Library.)

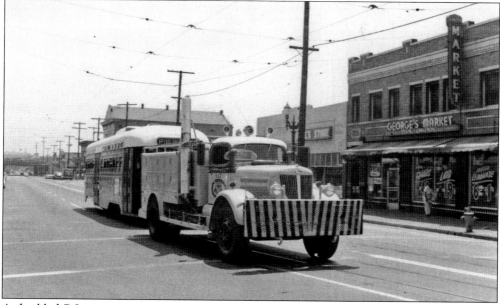

A disabled P Line streetcar gets a tow from "Bertha," or White-built truck No. 147, on Pico Boulevard just west of the Harbor Freeway in 1962. (Courtesy Metro Library.)

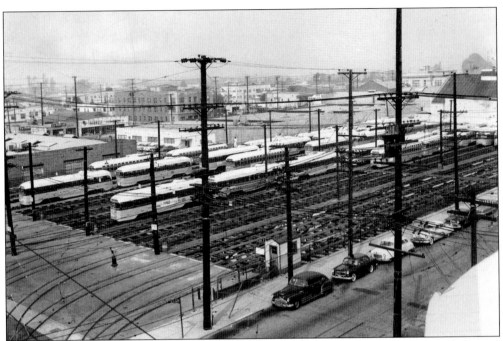

This is a *c.* 1962 panoramic view of the Georgia Street South Yard of Division 20, formerly known as Division Four. (Courtesy Metro Library.)

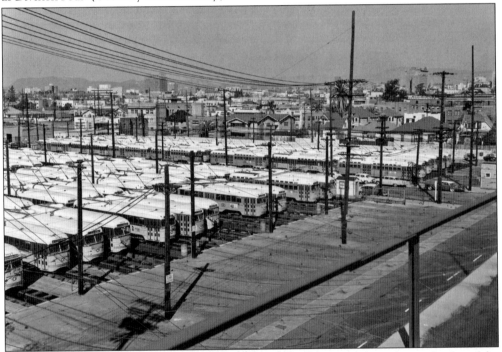

Another *c.* 1962 panoramic view, taken from across Georgia Street at about the south edge of the Division 20 South Yard, looks beyond to the north yard. The yards, fronting on Georgia Street, were separated by Twelfth Place. Both yards and streets have been obliterated, and this area is now occupied by the Los Angeles Convention Center. (Courtesy Metro Library.)

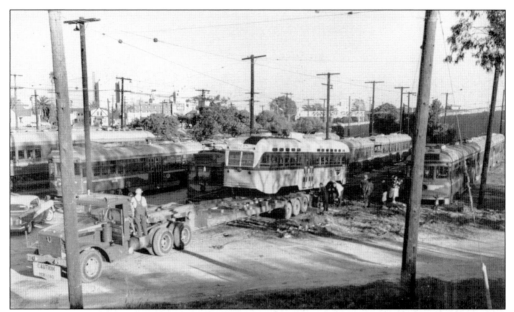

LAMTA Streamliner No. 3148 is unloaded at Long Beach's Morgan Yard in February 1960. Equipped with a set of standard-gauge tracks borrowed from the Municipal Railway of San Francisco, it would be tested on six test trips of the Pacific Electric Los Angeles–Long Beach route to determine the P-3's usefulness on the line. Once the test was over, it was trucked to the South Park Shops and the borrowed trucks returned. On its own trucks, it returned to the P Line pool, and nothing further was heard. The Los Angeles–Long Beach rail service, over the last PE line serving passengers, ended in April 1961. (Courtesy Metro Library.)

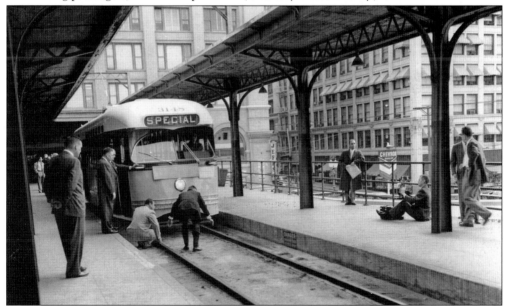

The now-green PCC poses for "photograph opportunities" with LAMTA officials at the Pacific Electric elevated station at Sixth and Main Streets during one of the 1960 test trips. PE's parent, Southern Pacific, kept creating roadblocks in an effort to get passenger service off all PE lines. (Courtesy Metro Library.)

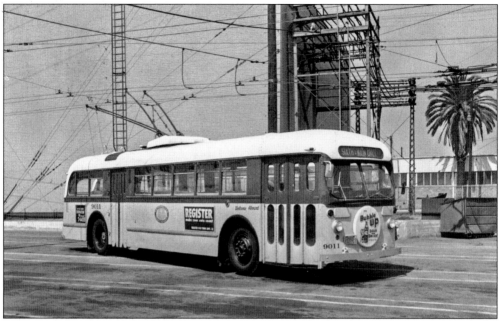

The two trolley bus lines kept running until the 1963 end of electric public transit in Los Angeles. Here Bus No. 9011 (from the middle batch) poses at Division One at Sixth Street and Central Avenue, the sole LAMTA facility equipped for the electric vehicles. Behind the bus is the Division One substation. At the end, only 70 trolley buses were in service, one (No. 9109) was scrapped and the rest were in dead storage. All remaining buses were sold for reuse on the Mexico City public transport system. (Courtesy Metro Library.)

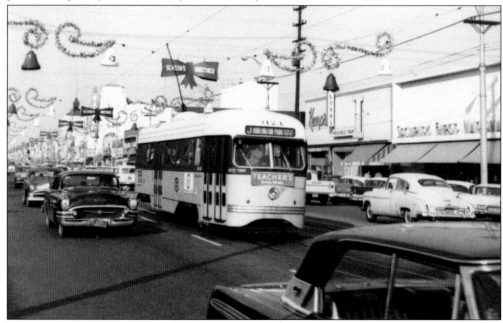

Streamliner No. 3124 is southbound on Pacific Boulevard in downtown Huntington Park during the 1962 Christmas season—the last yuletide to see operation of the J Line. (Courtesy author collection.)

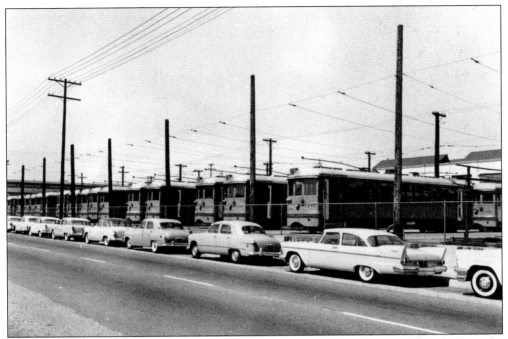

This April 1959 view from Fifty-fifth Street at a yard inside the South Park Shops looks at the retired non-PCC cars that were replaced on the S Line with streamliners the previous year. All but four went to the scrap yard. (Courtesy author collection.)

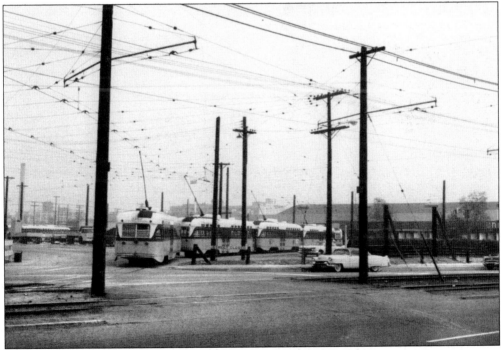

After running all night, Car No. 3003 was the passenger-carrying streetcar to pull into Division 20 at dawn on April 1, 1963. The last revenue streetcar on the V Line preceded it. On April 1, 1963, Angelenos awoke to a city with an all-bus transit system. (Photograph by Jim Walker.)

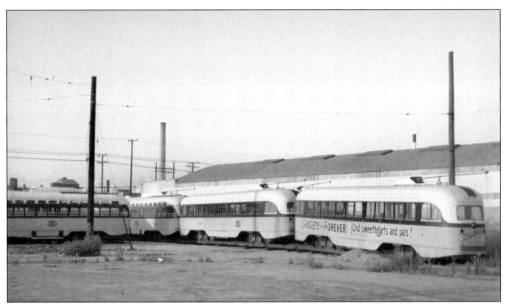

It's the day after the lines were converted, and all remaining streetcars are put into dead storage on a temporary track at Vernon Yard in the city of Vernon. Of the 165, three were taken to the Orange Empire Railway, two were sold to individuals, one was sold to a Colorado museum, and one (No. 3035) was scrapped after a 1956 collision with a Santa Fe Railway locomotive. The other 155 streetcars were sold for reuse; some to the Chile Nitrate Company in South America and most to the Cairo, Egypt, public transit undertaking. During that process, two more were dismantled for parts. (Courtesy author collection.)

The victor reigns here as the diesel bus, exemplified by the General Motors–built No. 5319, is seen at Division Seven in West Hollywood. Everyone thought the electric transit era was over.

Seven

AFTERMATH AND
RAIL REBIRTH
1963–PRESENT

In 1964, the Los Angeles Metropolitan Transit Authority was replaced by another public agency, the Southern California Rapid Transit District. The goal was to make rail rapid transit a reality. What finally tipped the scales was the Iranian fuel crisis of 1974. Then it finally hit home to people that the United States was dependent on foreign oil, and its unavailability might form a usable blackmail scheme. Further, it became apparent that the earth's fossil fuels were finite.

In 1980, Los Angeles County voters sanctioned a program to begin building a rail rapid transit system. Ground was broken in 1985 for the first route, the Metro Blue Line, between Los Angeles and Long Beach. Ironically, much of its route was that of the last Pacific Electric Red Car line between Los Angeles County's two most populous cities.

Other rail rapid transit routes followed, including the Green, Red, and Gold Lines. Under construction as this book goes to print is an eastside extension of the Gold Line, which is kind of resurrection of the Yellow Cars P Line to eastside communities as well as the Expo Line. Efforts continue in the region to expand rail lines even further.

The Yellow Cars are now just a memory, but the future is bright for rail transit in the Los Angeles Basin.

In this 1986 view, Los Angeles city, county, and transit officials conduct a ceremony to lay the first rail on the Long Beach Blue Line at Long Beach Boulevard and Willow Street in Long Beach. Much of the Blue Line's route was used from 1902 to 1961 by the Los Angeles to Long Beach Red Car rail service. Although this is not strictly the rebirth of the Yellow Car, it is significant that rail is returning to the Los Angeles Basin. (Photograph by Jim Walker.)

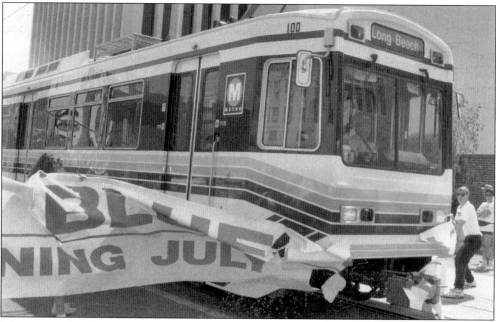

It's opening day for a rail transit renaissance in Los Angeles, on July 1, 1990, as crowds greet the first Metro Blue Line train at Flower Street and Pico Boulevard. The last streetcar stopped running on March 31, 1963, and no one then believed there would ever again be rail transit in Los Angeles. (Courtesy Metro Library.)

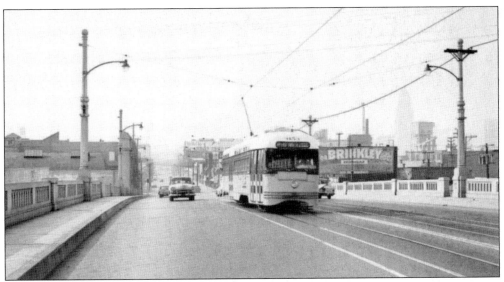

A PCC crosses the First Street Bridge over the Los Angeles River in 1963 en route to many East Los Angeles neighborhoods via the P Line. This line would be converted to buses in 1963. Building the eastern extension of the Metro Gold Line would require widening this bridge but retaining its original architecture. (Courtesy Metro Library.)

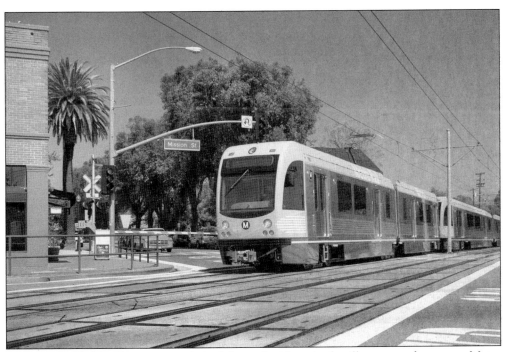

This group of light-rail cars, some of which have already arrived, will augment the present Metro Gold Line cars now in use between Los Angeles's Union Station and Pasadena and also its eastern extension. The cars are from Ansaldo Breda, an Italian car builder. One of the gray-liveried cars is seen on test runs in South Pasadena.

The Yellow Cars ran under many banners, and some are displayed on this page. The top images show that many streetcars and buses never bore a logo, just the name of Los Angeles Railway with a period at the end. Even this name was not depicted on later liveries, just the fleet number. In the bottom image, it is seen that the Los Angeles Railway did have an emblem, although it was used just on advertisements and was never applied to a vehicle. The third logo (bottom, left) is this "LARy" emblem, which was used by the builders of Birney Safety Cars and a few early buses. But when they were repainted, out went the logo, and either the company name was spelled out or just fleet numbers were applied. The fourth image is the Los Angeles Transit Lines' emblem, the same one that was used on most National City Lines properties. This emblem was part of the livery applied to the fleet. The fifth logo is that of the last operator of the Yellow Cars, the Los Angeles Metropolitan Transit Authority, which adopted a light green, dark green, and white paint scheme.

BIBLIOGRAPHY

Fredericks, William B. *Henry E. Huntington and the Creation of Southern California.* Columbus, OH: Ohio State University Press, 1992.

Myers, William A. and Ira L. Swett. *Trolleys to the Surf.* Glendale, CA: Interurban Press, 1976.

Post, Robert C. *Street Railways and the Growth of Los Angeles.* San Marino, CA: Golden West Books, 1989.

Swett, Ira L. *Los Angeles Railway—Interurbans Special No. 11.* Los Angeles, CA: Interurbans, 1951.

————. *Los Angeles & Redondo—Interurbans Special No. 20.* Los Angeles, CA: Interurbans, 1957.

————. *Die Day in L.A.—Interurbans Special No. 35.* Los Angeles, CA: Interurbans, 1964.

Walker, Jim. *Pacific Electric Red Cars.* Charleston, SC: Arcadia Publishing, 2006.

————. *The Yellow Cars of Los Angeles.* Glendale, CA: Interurban Press, 1977.

ACROSS AMERICA, PEOPLE ARE DISCOVERING SOMETHING WONDERFUL. *THEIR HERITAGE.*

Arcadia Publishing is the leading local history publisher in the United States. With more than 3,000 titles in print and hundreds of new titles released every year, Arcadia has extensive specialized experience chronicling the history of communities and celebrating America's hidden stories, bringing to life the people, places, and events from the past. To discover the history of other communities across the nation, please visit:

www.arcadiapublishing.com

Customized search tools allow you to find regional history books about the town where you grew up, the cities where your friends and family live, the town where your parents met, or even that retirement spot you've been dreaming about.